W9-BZF-209

Photography Without a Camera

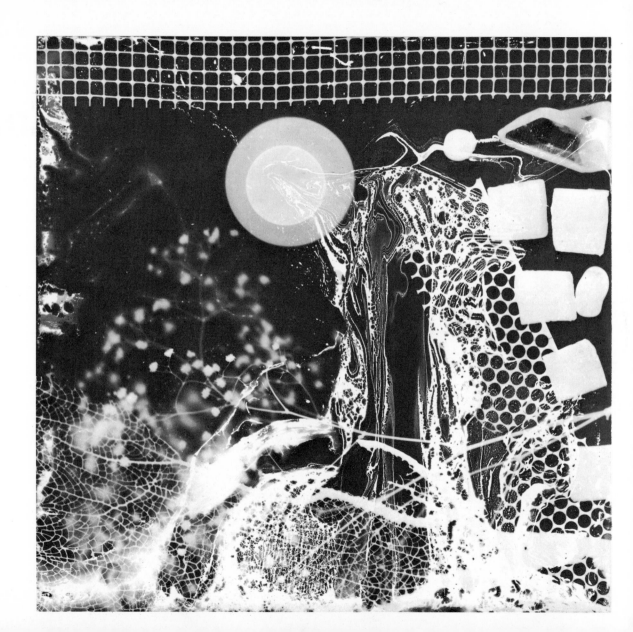

Photography Without a Camera

PATRA HOLTER

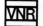 VAN NOSTRAND REINHOLD COMPANY
NEW YORK CINCINNATI TORONTO LONDON MELBOURNE

Library of Congress Catalog Card Number 75-176079

ISBN 0 442 25791-0

All photcgrams by the author except where otherwise
indicated. Photographs of students taken by the author
at the Quaker Ridge School in Scarsdale, New York.
Drawings by the author.

Paper edition published by Van Nostrand Reinhold Com-
pany in 1980
A Division of Litton Educational Publishing, Inc.
135 West 50th Street, New York, NY 10020

16 15 14 13 12 11 10 9 8 7 6 5 4 3 2

To Sig and Cap

ACKNOWLEDGMENTS

Mr. Peter Bunnell, Associate Curator, Department of Photography, The Museum of Modern Art, for his helpful suggestions and co-operation in searching out illustrative materials, and for permission to reproduce a print from his personal collection.

Mr. Edson B. Pierce and Mr. David Conquest, Eastman Kodak Company; Mr. Sidney Weisser, The FR Corporation; Mr. Dennis L. Liddell, GAF Corporation; Mr. Leslie G. Nichols, Supre-Print Corporation; and Mr. Robert Brown, E. I. Du Pont de Nemours & Co., Inc. for their technical information and aid.

Barbara Klinger, editor, for her invaluable suggestions and assistance in editing this book.

Ruth Sherman for her assistance in overall creative consultation.

Mr. H. M. Kinzer, Executive Editor, *Popular Photography Annuals* for his co-operation and consultation on a variety of technical details.

Mr. Dennis Martin, photographer, for his generous technical assistance.

Joan and Harry Bogdos, for their help in furthering experiments detailed in this book.

My appreciation also to: Mr. Albert Hurwitz, Coordinator of the Arts, Newton Public Schools; Mr. George Cope of The Workshop for Learning Things, Newton, Massachusetts; Mr. Ken Roberts, art teacher, Burr Elementary School, Newton, Massachusetts; Mrs. Diane Szakonyi, kindergarten teacher, and Mrs. Harriet Mishkoff, Quaker Ridge School, Scarsdale, New York; Miss Toni Giangrande, fifth-grade teacher, Edgewood School, Scarsdale, New York; and Dr. Michael F. Andrews, Chairman of The Department of Synaesthetic Education, Syracuse University.

Finally, I would like to express my deep appreciation to the Professional Development Committee of the Scarsdale Public Schools, for its support in this project.

And special thanks to Mr. Helmut Gernsheim, writer and photographic authority, for his contributions to the historical section of this book.

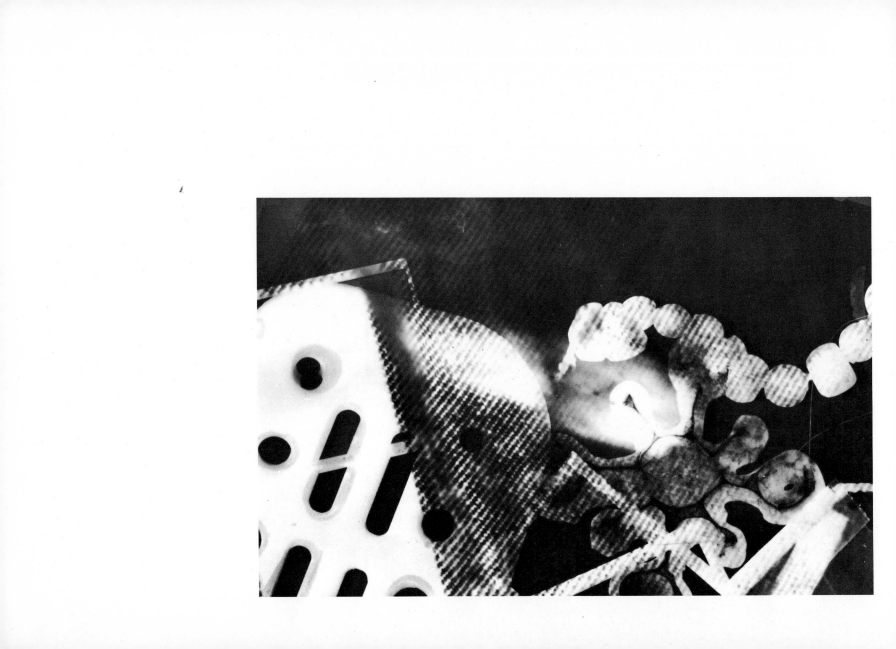

Contents

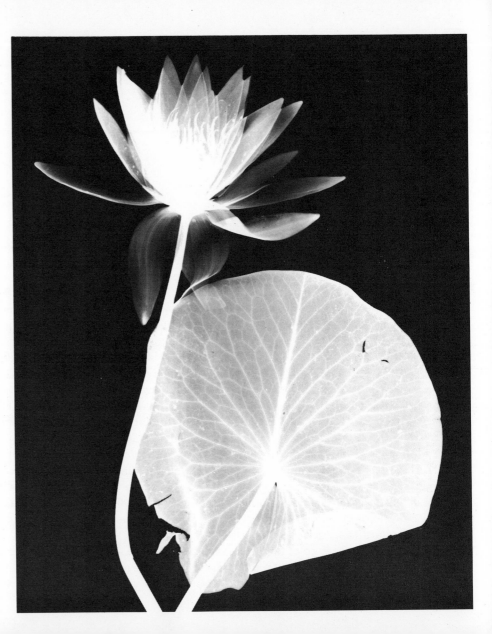

Sister Mary Alice: "Water Lily," Radiograph. (Permission of the artist.)
An x-ray machine was used to create sensitive composition of a leaf
and flower.

Preface

After working with students in photography for a number of years, I found that they produced some of their most exciting work when they used only photographic chemicals and papers with no camera involved at all. The light-sensitive paper became an intriguing new medium for them. The paper is comparatively slow in speed (it is less sensitive to light than camera film is), and the students could take their time working with it. They became totally absorbed in the seemingly unlimited potential that this new medium offered.

These students were experimenting with the basic elements involved in making photograms. Creating pictures without a camera is exciting because so many different techniques and forms are utilized, approaching both the arts of photography and painting. In their simplest form, photograms are made by arranging a variety of objects on light-sensitive paper, exposing the arrangement briefly to light, and simply developing the latent photographic image. Exciting images of great design value can be produced. Definable subject matter can appear in the final images, but photograms lend themselves best to non-objective design. There are few other mediums that will allow the artist to obtain such a great range of tonal values and spacial effects, or that can so successfully develop the sensitivity of the eye for positive and negative shapes. Consequently, creating photo-grams can play an important part in the student's beginning experiences in darkroom photography. However, photograms become most intriguing when explored as a separate art form.

Many degrees of complexity exist in making these pictures. An experienced artist or teacher could find himself avidly involved in the art, but a very young child could also enjoy making photograms on an elementary level. There is a great variety of materials, methods, and techniques that can be used in making photograms on all levels.

One of the best features of photography without a camera is that it is a relatively inexpensive process. It requires only a minimum of equipment. The prints can be made in daylight or in a darkroom, with or without an enlarger, and in color or in black and white.

This book offers guidelines for making photograms and other photographic pictures without a camera, but there are no fixed rules. One of the primary concerns of an artist is discovering what a material can do. Photography without a camera offers the ideal medium for experimentation. With the many types of papers, films, and other photographic supplies available, the range of possibilities is very great. Illustrations throughout the book will show the reader many accomplishments by artists and students who have enjoyed working in this medium.

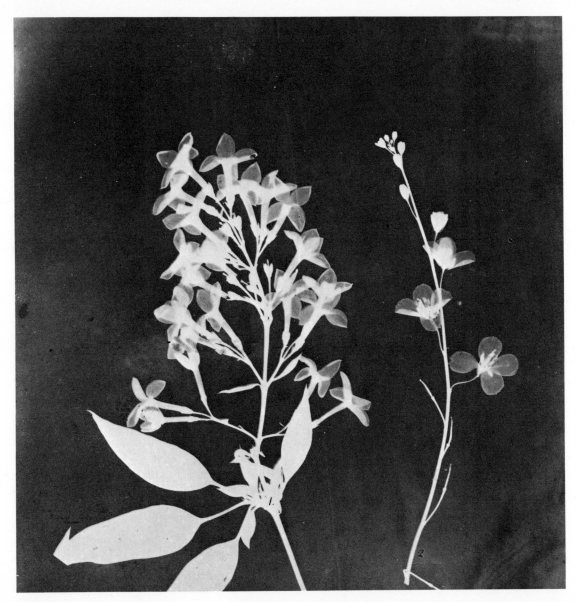

William Henry Fox Talbot: "Photogenic Drawing of Field Flowers," 1839. (The Metropolitan Museum of Art, New York City, Harris Brisbane Dick Fund, 1936.)

1 The Past Shapes the Present

The relatively new art of photography, relying on the elements of light and chemistry, has shaped the development of both camera and cameraless image-making. How was this accomplished? In order to explore a present-day art form, it is essential to delve into the past, into the roots from which it emerged.

As early as the thirteenth century, scientists knew that an image could be formed in a darkened room by light entering from a small hole in one wall and projecting the external view onto the opposite wall. This projection resulted in an inverted image formed on the wall's surface. Four centuries later, this principle was applied to portable structures and finally to a small box which was called the "dark chamber" or "camera obscura" (the forerunner of our modern-day camera). By then various lenses and mirrors had been added which righted and sharpened the image. These optical devices were used by artists to reflect images onto their drawing paper as an aid in sketching. The camera thus provided the optical means for obtaining images, but it was not until the nineteenth century that a method was found to record the images photographically. The problem of capturing a permanent and tangible image was first investigated by scientists working without cameras.

Almost nothing was known about light-sensitive chemicals when, early in the seventeenth century, Angelo Sala, an Italian scientist, noted the action of sunlight upon powdered silver nitrate, which turned black on exposure. As time went on, other scientists independently became aware of the phenomenon. In 1725, Johann Heinrich Schulze, a German professor of medicine, accidentally produced the first photographic image of which we have any record. He observed the sun's action on a silver nitrate and chalk mixture, over which he had placed some cutout letters. When the letters were removed, white images remained on the areas that had been covered, while the exposed background had turned dark in color. As no camera was used, the image he obtained can be termed a photogram.

In 1800, basing his experiments on those of Schulze, Thomas Wedgwood, of the famous Wedgwood pottery family, found that he could obtain images by placing objects on top of light-sensitive material. In collaboration with Sir Humphry Davy, a noted chemist of that time, he produced silhouetted images of insects and leaves on white leather coated with silver nitrate. However, they were unable to discover a method of fixing these images (stopping the action of the light upon the chemical so that a print could be viewed in daylight without having the image gradually blacken all over).

By using a different light-sensitive coating, bitumen of Judea, Nicéphore Niepce succeeded, between 1822 and 1826, in making a number of photograms on both glass and pewter plates. These were copies of engravings produced by waxing the printed paper and placing it on the sensitive plate. Light passed through the transparentized paper and made the bitumen insoluble except where the inked lines of the engraving kept the light from reaching the bitumen. Niepce then dissolved the unexposed parts of the light-sensitive coating by washing the

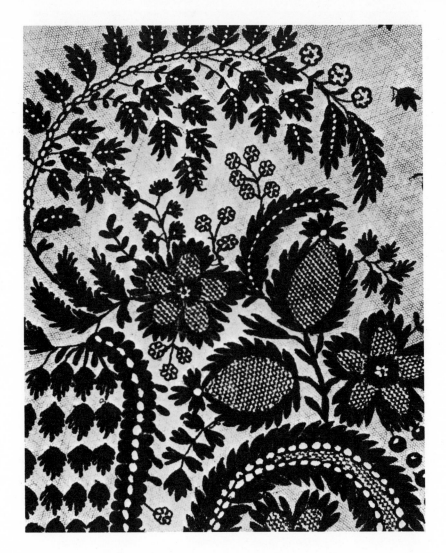

William Henry Fox Talbot: "Calotype of Lace," about 1843. (George Eastman House Collection, Rochester, New York.)

plate with oil of lavender and turpentine. He thus obtained a permanent, direct positive picture, with the bitumen providing the highlights and the bare metal providing the shadows. He called the pictures heliographs or sun drawings, and used the same process to take pictures with a camera.

After working on heliographs with Niepce, in 1839, Louis Daguerre devised his own photographic process, using iodized silver plates in place of pewter plates sensitized with bitumen. Daguerre found that, instead of waiting for the image to appear as a result of the action of light alone, he could develop a latent image on the exposed plate by fuming it with mercury vapor. This process, called daguerrotype, reduced the exposure time from hours to minutes and made it more feasible to use the plates in cameras. The pictures were fixed with hyposulfite, which dissolved the unexposed light-sensitive material. Though the photographic process resulted in very thin, negative images, the shiny surface of the silver plate on which the images appeared reflected light and reversed the negative picture to a positive one, making daguerrotype a direct, positive process.

Experimenting independently, between 1834 and 1839, William Henry Fox Talbot made many photograms on paper, using a process he called "photogenic drawing." In 1835, he discovered a method of fixing the images and began using the process for taking camera views as well as for photograms. In both cases, photogenic drawing produced a negative image; the light and shadow areas were the reverse of the viewed images. This laid the foundation for the use of paper negatives to obtain positive copies of a single picture. Talbot, however, did not reveal his method of photogenic drawing until 1839, the same year Daguerre revealed his process. During the first years of photographic history, before these methods for developing, for fixing, and for printing positives from negatives became known, making photograms became a pastime for many amateurs.

For photogenic drawing, Talbot obtained a sensitized paper by using silver nitrate and a weak solution of common salt

(sodium chloride) to form silver chloride. He placed an object on the paper and let the light from the sun develop the negative print. The picture was then bathed in an ordinary salt solution, which dissolved the light-sensitive material (silver chloride) from the paper, and the image was made permanent. Talbot later used sodium thiosulfate as a fixing agent, a suggestion put to him by Sir John Herschel. When fixed, the negative could be printed by placing it in contact with another piece of sensitized paper, exposing this to light, and fixing the positive print. With sensitized paper in the camera, a negative could be made with an exposure of from thirty seconds to one minute and after being fixed could be printed as a positive.

In 1841, Talbot patented a greatly improved process, which he first called calotype (from the Greek words *kalos* and *typos,* meaning beautiful impression) and later renamed Talbotype. By sensitizing the paper with silver iodide and by developing the latent image with gallic acid, he could greatly reduce the required exposure time to a second or less. The resulting negative could be made more transparent by waxing or oiling the paper and could be printed as a positive on photogenic drawing paper (silver chloride) using only sunlight to develop it.

Other photo-chemical processes were also investigated. Cyanotype, for instance, introduced by Sir John Herschel in 1842, depended on the interaction of cyanogen and iron to produce a slow-acting sensitive coating for paper. After the paper was exposed in contact with an object, it was washed in cold water and the image became permanent. Mrs. Anna Atkins employed cyanotype in copying her important collection of British seaweed. The original volumes are housed in the British museum. Cyanotype was adapted for commercial use in 1881 by Marion & Co., Photographic Publishers, and went under the name ferroprussiate, or blue, process. It was used for copying documents.

Though photograms were instrumental in advancing the photographic processes, after these early experiments, the idea of photography without a camera remained dormant for nearly

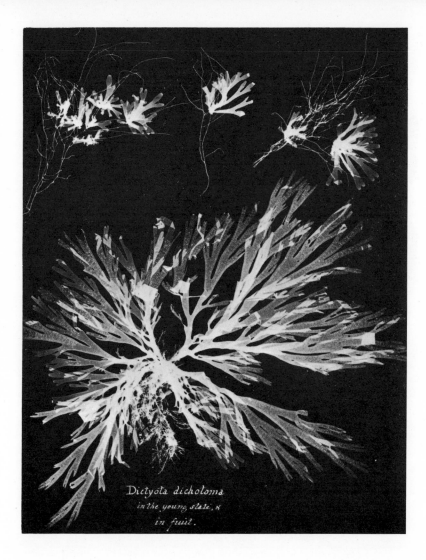

Dictyota dicholoma in the young state, & in fruit.

Anna Atkins: ''Cyanotype of British Seaweed,'' 1864. (By permission of the trustees of the British Museum—Natural History, London, England.)

13

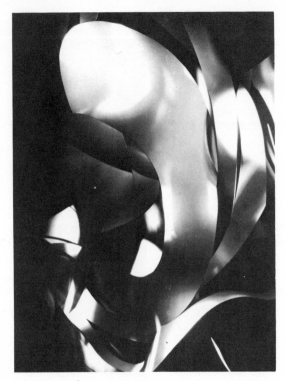
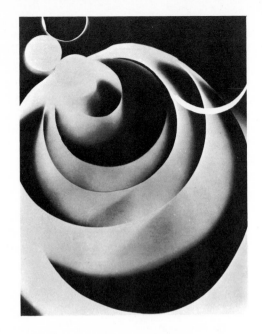

a century. As films were improved and optical devices were refined, photographers were understandably more interested in exploring the aspects of life and nature which the camera could capture so well. Photographers influenced painters to render detail with the same precision, but in the 1890's they themselves came under the influence of the soft, blurred images of impressionism, which they tried to imitate by using soft-focus lenses and canvas screens. Several subsequent movements in art, vorticism and dadaism among them, later inspired non-objective images in photography. In 1917, for example, Alvin Langdon Coburn created abstract images by photographing objects through mirrors. These pictures were termed Vortographs. How-

ever, with the exception of a few photographers, such as Gyorgy Kepes, who was also a design teacher, and Francis Bruguiere, the possibilities that photograms held as a modern non-objective art form were left to be explored by a group of painters.

In 1918, Christian Schad, a Zurich dadaist, created his own Schadographs by exposing strips of paper, string, and other two-dimensional materials on photographic paper. When Tristan Tzara, a member of the Zurich group, showed these prints to Man Ray, an American artist who had settled in Paris, Man Ray made similar pictures, which he called Rayographs, introducing three-dimensional objects to the medium. The use of translucent and transparent articles in addition to opaque ones also pro-

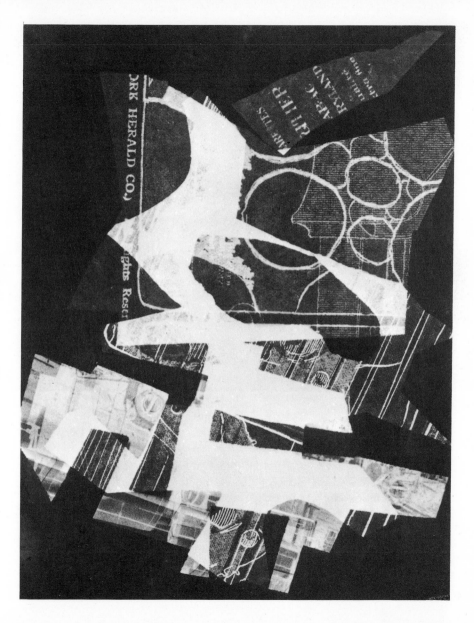

Opposite page: (Far left) Alvin Langdon Coburn: "Vortograph," 1917. (Collection of Peter C. Bunnell, New York City.) *(Center)* Francis Bruguiere: "Photo Design," c. 1926. (George Eastman House Collection, Rochester, New York.) *(Right)* Man Ray: "Rayograph," Plate #3 from *Champs Delicieux,* album of photographs with an introduction by Tristan Tzara, Paris, 1922. (Collection, The Museum of Modern Art, New York City.)

This page: Christian Schad: "Schadograph," 1918. (Collection, The Museum of Modern Art, New York City.)

duced new effects. Different methods of using light (diffused, deflected), varied time exposures, interrupted development, double printing, and numerous other experiments resulted in the creation of exciting new works of art.

In 1922, László Moholy-Nagy, inspired by some Rayographs he had seen, produced his own cameraless photographs, which he termed "photograms." Some of the techniques used in making photograms were later adapted for use in advertising by photographers in Europe and America. Moholy-Nagy considered the photogram to be the "real key to photography."

Today many photographers are working with photograms and related cameraless techniques. Pierre Cordier, a Belgian photographer, uses the localization of alternative or simultaneous action of fixing and developing chemicals to realize his "Chimigrammes." Robert Heinecken, a photographer from California, contact prints pictures from magazines directly onto photo-sensitive paper. Chapter 10 shows more illustrations by these and other contemporary artists working with photogram techniques and variations of these techniques.

Much photographic genius is born in the darkroom. This is why photography without a camera is such an exciting and versatile art form, one that holds great promise and many creative challenges for both the professional and non-professional artist or photographer.

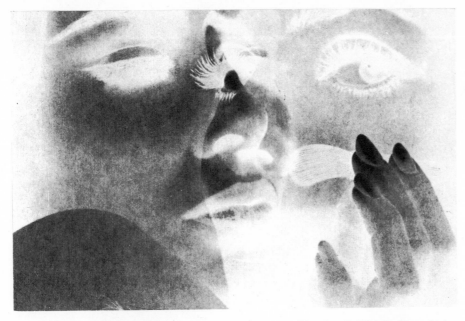

Robert Heinecken: From the series "Are You Rea," 1964-68. (Permission of the artist.)

The Language of Photograms

Photographic nomenclature has changed throughout photographic history. As new discoveries were made in the field of photography, it was necessary to define both the technical and aesthetic aspects of the craft.

As discussed in the previous paragraphs, the first photographic experiments were undertaken without a camera and resulted in images we now call photograms. These images were referred to in various ways by their early inventors. Wedgwood

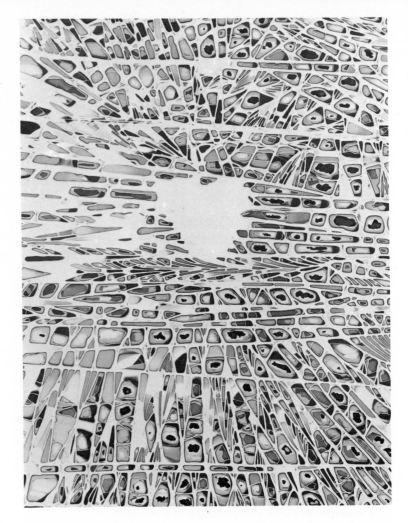

Pierre Cordier: "Chimigramme" (detail), 1966. (Permission of the artist.)

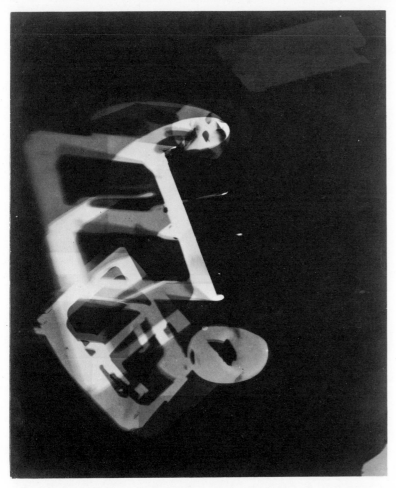

László Moholy-Nagy: "Photogram," 1929. (Collection, The Museum of Modern Art, New York. Gift of James Johnson Sweeney.)

called them "profiles by the agency of light"; Niepce termed his pictures "heliographs"; and Fox Talbot dubbed his work "photogenic drawings" or "sun pictures."

The word "photogram" and the word "photograph" are both derived from Greek origins. The first part of each word comes from the Greek word *photos* meaning "light." "Graph" comes from *graphos* and "gram" from *gramma,* both meaning "written." The word photography seems to have been used first. Written "photographie" by J. H. Mädler, it appeared in the publication *Vossische Zeitung* on February 25, 1839, but the term had been used even earlier by Herschel, who suggested in a letter to Talbot that the word "photographic" be substituted for "photogenic."

In about 1858, many people thought that "photogram" would be a more correct noun than "photograph" for all pictures produced on light-sensitive materials. The controversy arose out of the new word "telegram," which had recently come into use and was the subject of a spirited debate in the *Times.* The word "photogram" was occasionally adopted during the succeeding period for titles of photo manuals. There was even an English magazine by that title in the 1890's. However, the term used in this sense did not withstand the test of time and "photography" and "photograph" came to be the official terms.

In 1922, the painter László Moholy-Nagy suggested that the name "photogram" be applied to cameraless photography and this, over the years, has come to be the accepted terminology. It is also interesting to note that photograms have become personalized by the artists who made them. Man Ray called his work "Rayographs" and Christian Schad's works were labeled "Schadographs" by the dada poet Tristan Tzara.

2 On Making Photograms

Making photograms means working with non-objective ideas as well as with realistic images, and the artist beginning to work in this medium should explore every avenue of invention open to him. It will be necessary to experiment in order to arrive at new ideas, and the accidental introduction of new techniques to the medium can produce additional design qualities yet unknown. Happy or unhappy accidents, as the case may be, will no doubt play an important part in making the first prints. After working on photograms for a while, a good control of technique will be gained and less will be left to chance. But increased discipline in the approach to printmaking need not limit the creative possibilities.

Design Objects

One of the first things to consider when making photograms is the assortment of objects that will be needed in order to print. Choose objects for their unique qualities. Unusually shaped opaque items make good silhouettes. Transparent or translucent materials, such as plastic, glass, or thin papers, should also be selected, since light will penetrate these surfaces during exposure and a variety of gray tones can be achieved. Three-dimensional objects will give depth to the prints and will sometimes produce soft, shadowy outlines. Introducing textured surfaces such as a screen or patterned glass will also enhance the final picture.

The technical elements to consider in making photograms are: the light-sensitive papers or films that will carry the images, the light source that will start the photochemical process, and the chemicals that will develop and fix the images. While subsequent chapters will deal with these elements in more detail, a brief introduction to the chemicals, the papers and the exposure techniques you will be using will enable you to choose the appropriate materials.

Chemicals

Though some techniques do not require developer, stop bath, and fixer, most photographic papers and films are processed with these solutions. Separate developers for paper and for film

are available but are not really necessary, because some paper developers, such as Kodak's Dektol, can be used to process film as well, and there are also universal developers that are designed to work with both paper and film. When mixing developers, follow the instructions that are supplied with them and use a measuring vat to add water in the proper proportions to make the stock solution. Some developers require a further dilution, usually one part of stock to two parts of water, to make a working solution.

Fresh stock can be stored for one to six months in dark-colored, opaque bottles. Gallon-size, plastic containers are the most suitable and, to economize, empty bottles from detergents or other household liquids can be cleaned and used. Separate bottles should be used to store worked solutions (developer that has been used and can be reused). Never pour a worked solution into a container of fresh stock. It will weaken the good solution and in some cases even contaminate it. You can tell when a worked solution is exhausted and no longer suitable for use when it turns dark in color or when developing time becomes excessively long.

Stop bath is made by diluting 28% acetic acid with water. This solution is used to stop the action of the developer before you put the print in the fixer. Generally, you can make this solution in a tray as you need it and discard it when you are finished printing. You can, however, store the worked solution if you wish to economize. Commercially prepared stop baths have an indicator added to them which turns the solution purple when it is exhausted and cannot be used any more.

Fixer is used after development to dissolve the unexposed light-sensitive emulsion on paper or film. It can be made by dissolving sodium thiosulfate crystals in water or by diluting commercial acid fixer with water. Acid fixer with hardener is the best type to use for most processes, but some techniques, such as color toning and sun prints on printing out paper, require pure thiosulfate crystals. Pour the fresh solution into a dark-colored, gallon-size bottle. Worked solutions can be stored in sep-arate bottles. To determine if the worked solution is still good, a small bottle of hypo check can be purchased. Add a few drops to the fixer; if crystals form and will not redissolve upon mixing, the fixer is exhausted.

When they are mixed, fixer and developer look the same and it is sometimes easy to confuse the two. Label each bottle of solution so there is no mix-up. If there is any confusion, you can tell one solution from the other by dipping your finger into each. Developer feels slippery but fixer feels like water.

Besides labeling each bottle of solution, it is a good idea to label each tray with the name of the chemical that has been used in it. That way, if there is any chemical residue left in the tray after it has been used and cleaned, it will not contaminate the new solution when the tray is used again. Two separate pairs of tongs should also be used for handling the print in the solutions. Use one pair only to transfer the print from the developer to the stop bath; try to keep the instrument from touching the stop bath solution. Use the second pair of tongs to remove the print from the stop bath and place it in the fixer. Rubber-tipped tongs are desirable because they will not scratch the prints.

The types of developers, stop baths, and fixers described here are used for all papers and films mentioned in the chapters on darkroom and roomlight printing. Specific brands are listed in Supply Charts.

Papers, Light Source and Exposure

With the exception of papers developed by sunlight, the papers used in photography without a camera fall into two categories: regular photographic papers, which are suitable for working in the darkroom; and the less-sensitive roomlight handling papers, which can be used in subdued light. Photographic papers include enlarging, or projection, paper (silver bromide emulsion), which is very sensitive to light, and contact paper (silver chloride emulsion), which is slower in speed and requires a longer expo-

sure. Roomlight handling papers, which are even slower in speed, must be obtained from graphic art supply houses. (The sheet films used are also graphic art supplies and can be obtained from the same source.) See the Supply Charts for manufacturing sources and for more information on other characteristics of paper, such as size, weight, and grade.

The light source you use for making your pictures will be related to the kind of paper or film you are working with. For example, the amount of light transmitted by a bare 100 watt bulb is more difficult to control than light from a regular photographic enlarger. Therefore, it would be better to use such a bulb for exposing the less-sensitive contact paper, while a bulb of lower wattage, or an enlarger, would be a more appropriate light source for exposing enlarging paper. Roomlight papers generally require longer exposures. Detailed exposures are given in Chapters 6, 7 and 8.

Exposure for the prints is usually satisfactory if the light source is kept at a height of about 2 to 4 feet above the paper, but try experimenting with single and multiple lighting sources from various heights and angles. Reflected light from a polished metal surface or diffused light are both dramatic ways of illuminating the paper. Directing the light source through something (wire, netting) outside the paper areas for exposure will cause interesting shadows to appear in the final print. Linear effects can be achieved during exposure by the technique of drawing with a pinpoint flashlight.

Shifting objects during brief, separate exposures will result in varying shades of gray, and the added appearance of shadowy movement is intriguing. Consider also the movement of water caught in crumpled cellophane or in a plastic bag placed over the paper for exposure.

A large variety of pictures can be achieved with images painted on sheets of glass and placed on photo paper for exposure (clichés-verres technique). Examples of clichés-verres are included in Chapters 6 and 9. Unusual lighting and printing techniques can be found in Chapter 9.

Composition

Further interest can be added to photograms by using various color toners. All of the papers, except those used in sun prints, can be colored with standard toners after they have been processed in a standard black-and-white developer. Most of the films can be handled in the same way. In addition, contact and enlarging papers, and some films, can be developed and colored simultaneously with FR Develochrome. Whether the photogram is in color or in black and white, the primary impact will still be created chiefly by the objects chosen, the exposure techniques, and the skill in combining these elements to obtain a pleasing composition.

As with any composition, it is best to plan around a center of interest, possibly using one object as the basis for the design. When too many unrelated items are used for a composition, the picture is apt to look like something "blew up" and left fragments ·scattered all over the paper. Consideration of positive and negative shapes is essential when working in black and white, and a balanced division of space is necessary to insure good design. Superimposing small and large shapes, texture, and line, and repetition of elements within the same design will help draw the composition together.

A combination of good design elements and imagination should provide many hours of creative experiments, with highly individualized and unusual photograms as the tangible, artistic result.

3 Sunprints

Making sun-print photograms is an ideal way to introduce very young children to the elements of photography because no darkroom is required. Unlike photograms produced by more complex methods, sun prints are developed directly on light-sensitive paper by means of the sun's rays. They do not require artificial light for exposure or chemicals for development. Though it is also possible to use a regular white light for exposure, the natural brilliance of the sun provides the easiest and least complicated method of exposure and development. After development, sun prints on photographic paper can be fixed in a mild chemical solution. This process of development by sunlight alone was actually the first step in the creation of a photographic image. Early experiments in photography did not include chemical development.

Photograms developed by the sun alone can be made on either printing out paper or ordinary construction paper. Sun prints can also be made on light-sensitive blueprint paper with the images being fully developed by water, or on Diazo paper, which is developed by ammonia fumes. The effectiveness of blueprint paper is illustrated by the number of artists currently using it for aesthetic works of art rather than as a copying aid. Many of these drawings, such as the work of Ushio Shinohara (page 121), are currently housed in museum collections. Xerox prints (which are produced by electrical charges rather than chemical development) are also taking their place as a valid art form.

Additionally, there are many natural materials, such as pine wood, which are light-sensitive and which can be used for making sun prints. The juices from some natural materials (carrots and red cabbage, for example) make a good light-sensitive coating for paper and can be applied to making sun prints.

One unique application of the reaction of certain materials to heat and light has been developed by Alan Sonfist, a New York City sculptor, who places light-sensitive objects in plexiglass so that they change continually upon prolonged exposure to the elements (page 114).

On Printing Out Paper

The process of making sun prints can be simplified by using printing out paper (P.O.P.). This is the same type of paper that portrait photographers use in making a proof for the model to view before deciding on a final pose. Proofs fade out, but a simple way exists to make the images permanent.

Equipment

TABLE OR WINDOWSILL
1 TRAY *(ANOTHER TRAY WILL BE NEEDED IF COLOR IS BEING USED)*
TONGS
TABLESPOON MEASURE
QUART MEASURE
BLOTTERS
SINK
ASSORTMENT OF OBJECTS WITH WHICH TO MAKE DESIGNS

Supplies

PAPERS:
KODAK STUDIO PROOF F *(PRODUCES A DARK BROWN COLOR)*
GAF PROOF GLOSSY *(PRODUCES A WARM BROWN COLOR)*
AGFA-GEVAERT P.O.P. *(PRODUCES A MEDIUM BROWN COLOR)*
FIXER:
SODIUM THIOSULFATE CRYSTALS *(SEE SUPPLY CHART)*
TONER:
VEGETABLE COLORS *(IF DESIRED)*
WASH *(THESE WASHING AIDS SPEED UP THE WASH TIME TO 10 MINUTES INSTEAD OF ONE HOUR. THEY ARE NOT NECESSARY, JUST CONVENIENT.)*:
FR HYPO-NEUTRALIZER
KODAK HYPO CLEARING AGENT

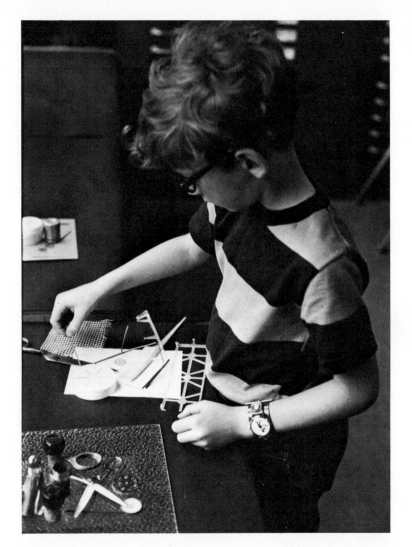

Making sun prints is especially appealing to young children. Second-grader David Cates begins by arranging objects on light-sensitive paper near a window.

In preparation for making sun prints, make the fixer by dissolving 5 rounded tablespoons of sodium thiosulfate crystals in 32 ounces of cool water (about 65°) in a clean tray or dishpan. A rinse bath for the finished prints should also be arranged in advance. The simplest method of washing prints is to put them in a sink filled with cool water. However, the rinse is much more thorough if fresh water is circulated throughout the rinsing time. Instructions for setting up a circulating rinse bath are given later in the book (page 54) under more advanced darkroom techniques. For classroom situations, the sink bath is adequate.

Have ready a good assortment of objects with which to arrange designs and put it within easy reach of the flat surface to be used for holding the paper. The P.O.P. should be

placed with the sensitive side up (the sensitive side is the shiniest side) on a table or windowsill where the sun's rays will focus directly on the paper. If the window has a shade to block the light, ample time can be taken to make the arrangement. If there is no way to shut out the sun's rays, then the design must be arranged immediately, because the paper will begin to develop as soon as it is exposed to light. If too much time is spent in making the arrangement, the final images will not be clear.

As the paper becomes exposed to light, the background of the sun print will begin to turn purple, leaving the covered areas of the paper white. It can be very exciting to watch the print slowly developing and to observe the chemical change on the paper. If the sunshine is very bright, the print will be fully developed in 5 to 10 minutes. If the sun is obscured, the paper may take 20 minutes to a half hour to reach full development. When the purple background becomes almost black in color, the print is completely developed.

After exposure, the design objects should be removed from the paper and the print should be set into the prepared fixing solution for 10 minutes. The dark purple background of the print will change to a brown color in the solution, and the finished print will appear brown with white images. Several prints can be fixed at once, but they should be lifted out of the fixer individually, with tongs, and gently shaken free of as much liquid as possible so as not to contaminate the clear water bath. Set the prints into the water bath for one hour.

If a shorter washing time is desired, wash the prints for one minute, immerse them in a hypo neutralizer, then wash them 10 minutes. If FR's Hypo Neutralizer is being used, immerse the prints in it for 5 minutes. Kodak's Clearing Agent requires a 2-minute immersion time. The prints should occasionally be agitated in both the fixer and the bath so they won't stick together. Blot the prints and either hand them up or lay them flat to dry. The prints may tend to curl up as they dry. This can be remedied when they are mounted, or the prints can be weighted down while drying.

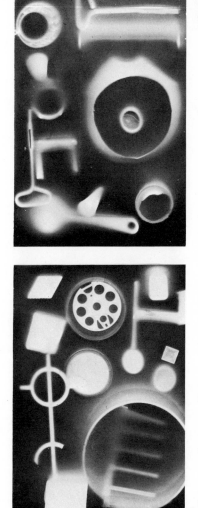

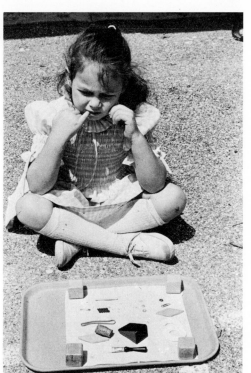

Above: Kindergarten student Joy Braverman patiently waits for the sun to develop the images on her photographic paper.

Top left: Sun print on P.O.P. By shifting some of the objects slightly during exposure, Leslie Fine created a double-image effect.

Left: Sun print on P.O.P. Jonathan Katz used a cylinder in the lower right-hand corner to give depth to his design.

23

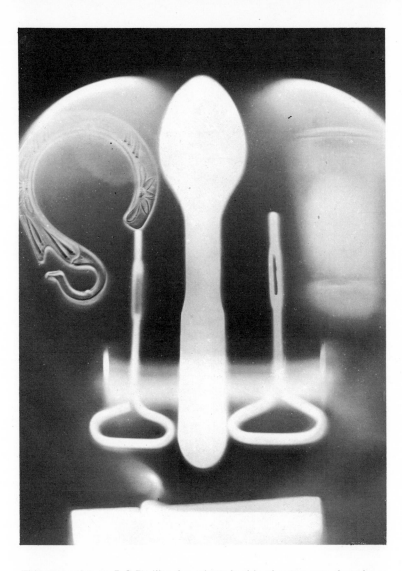

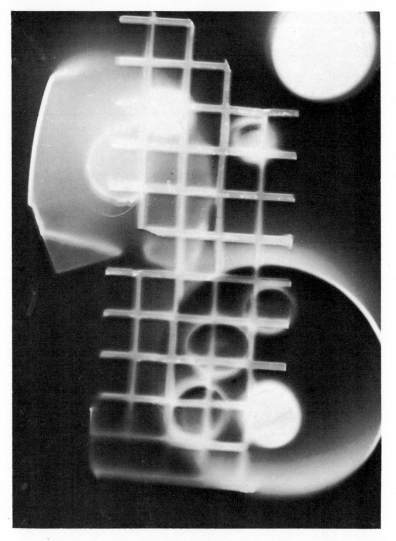

This sun print on P.O.P., like the others in this chapter, was done by a second-grader. Here, Jimmy Pollock used tin can keys, shower curtain rings, and a plastic spoon to form his composition.

Sun print on P.O.P. Douglas Moss superimposed a plastic grid over other objects and obtained a three-dimensional effect.

The images of prints on P.O.P. can be easily and effectively color toned by placing the print in a vegetable coloring solution immediately after fixing it. The color solution is made by mixing 2 tablespoons of vegetable coloring in a quart of water. More or less coloring may be added depending on the strength desired. After they have been colored, the prints are washed as usual for one hour.

Don't underestimate youngsters. The techniques are easy to master and, after they have made a few sun prints, they will probably begin to experiment. They might move objects during exposure to get multiple images; they might overlay objects, or try to achieve textural effects. They will no doubt come up with many surprises.

On Blueprint Paper

Using blueprint paper for printing is very practical because it is inexpensive (about 10 cents per square foot). It can usually be purchased at duplicating or blueprint companies. The paper comes in rolls of various widths; 24-inch or 36-inch widths are the most commonly stocked. An entire roll will rarely be needed, so just request the exact amount desired and it can be measured off the roll.

Blueprint paper has a relatively short shelf life if it has not been covered well and protected from light and air. Therefore, if, after you have stored the paper for a while, you find the paper no longer produces a clear image when exposed to the sun, discard about 3 feet from the top layer of the roll and use some fresher stock underneath. It is best to buy the paper as near to the time it is to be used as possible in order to be sure that it will be fresh.

The fixing agent for blueprint paper is easy to prepare and quite safe for small children to use. Simply mix one part 3% peroxide to eight parts of water, or mix about half a cup of the peroxide in a gallon of water. If more fixer is needed, just double

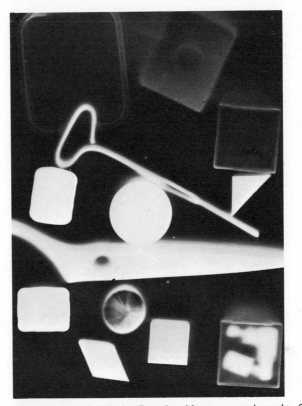

Sun print on P.O.P. by Douglas Moss, second grade. Opaque objects placed on the paper resulted in white images while the translucent plastic items resulted in darker images.

Equipment

TABLE OR WINDOWSILL
1 OR 2 CONTAINERS (PLASTIC TRAYS, DISHPANS, OR PAILS)
SINK (IN PLACE OF SECOND TRAY)
CUP MEASURE
QUART MEASURE
TONGS (IF DESIRED)
GLASS SHEET (IF DESIRED)
COMPOSING BOARD OR TRAY (IF DESIRED)

SCISSORS OR PAPER CUTTER
ASSORTMENT OF OBJECTS WITH WHICH TO MAKE DESIGNS

Supplies

BLUEPRINT PAPER
3% HYDROGEN PEROXIDE (AVAILABLE AT DRUG STORES)
WATER

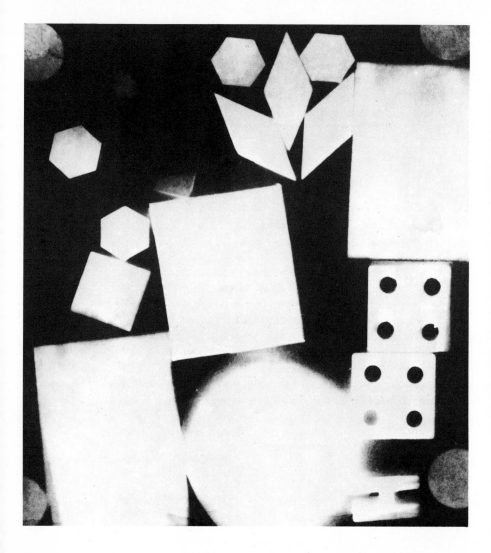

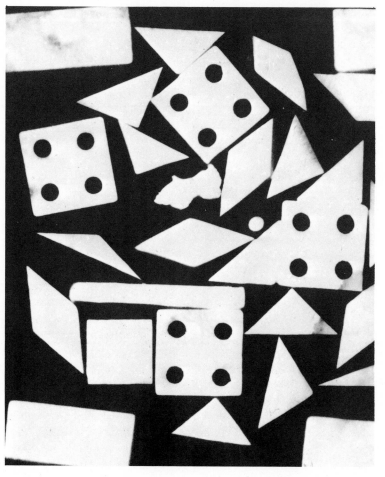

Sun print on blueprint paper. Kindergarten student Billy Thea used flat and three-dimensional items on his print. The three-dimensional objects created faint shadows.

Sun print on blueprint paper by Debbie Moscou, kindergarten. The use of only flat shapes produced sharp images.

26

or triple the formula. The fixer can be mixed directly in a tray, dishpan, or pail. A second container, or a sink, should be filled with cool water for rinsing the prints at a later time.

It is best to compose sun prints away from the light of the window. This would allow a suitable time to make the designs without having the paper fog up. About a half hour of room-light exposure is fairly safe for blueprint paper. Keep the paper not being used covered and away from the light. Have the sheets precut, or cut the sheets only as needed, to avoid unwanted exposure.

If the blueprint paper is first placed on a tray or board, the tray and composition can be carried to a windowsill or even out of doors for exposure to the sun's rays. A sheet of glass can be placed over the arrangement to keep the paper flat during exposure, or a glass sandwich can be made by placing a sheet of glass with beveled edges on a piece of sturdy cardboard. The glass and cardboard should be taped together along one side with masking tape. The paper and two-dimensional objects may be placed inside the sandwich for exposure. The paper can also be held flat just by placing a few heavy objects on the corners and incorporating the objects' shapes into the design. Flat objects produce the clearest shapes.

Make sure the blue side of the paper is face up when you place the design items in contact with it. Exposure time will depend on the strength of the sun. The background of the paper should turn slightly darker than its original color, while the covered portions remain the same color. The exposed areas do not turn a bright blue until the paper has been placed in water (the water in the fixing solution develops the print). If the print is too light after development, more exposure time is needed. A print that is too dark means that the arrangement has been in the sun too long. Generally, if the sun is very bright, an exposure time of about 1 or 2 minutes is adequate.

After the objects have been removed from the paper, the paper should be immersed in the fixer for a few seconds. When the background of the sun print becomes bright blue, leaving clear white or light blue images, the picture is ready to be rinsed. Place the print into the rinse bath for just a few seconds; then blot the print or place it on a paper towel to dry.

The results should be some unusual and personalized images that will inspire even further creative experiments with blueprints.

On Diazo Paper

Like blueprint paper, Diazo paper was originally intended for mundane purposes such as office duplicating work. But this inexpensive paper (it costs about a penny per sheet) is well suited to making sun prints. It produces a colored image on either a white or a different colored background (see Supply Chart for available color combinations) and it therefore offers more color possibilities than the other types of sun print papers.

The emulsion on Diazo paper contains azo dye and other light-sensitive chemicals. Exposure to sunlight causes the dyes on the paper to fade except where objects have been placed. (A sun lamp, photo flood, or ultraviolet lamp could also be used for exposing the paper.)

Even though Diazo paper has a low sensitivity to roomlight, some precautions should be taken to avoid inadvertent exposure. Take the sheets of paper from the package only as needed,

Equipment

TABLE OR WINDOWSILL
1 CONTAINER *(A DEEP, PLASTIC TRAY OR PAIL)*
CUP MEASURE
WIRE SCREEN WITH ¼-INCH HOLES
GLASS SHEET LARGER THAN THE TRAY OR PAIL BEING USED
BOARD OR TRAY *(IF DESIRED)*

ASSORTMENT OF OBJECTS WITH WHICH TO MAKE DESIGNS

Supplies

DIAZO PAPER OR DIAZO CHROME *(FILM)*
1 CUP AMMONIA

and arrange the design away from the window. The yellow side of the paper is the sensitive side, and the process for arranging and exposing the print is the same as for blueprint paper.

When the yellow color of the paper surrounding the objects placed on it fades and becomes totally white, the paper is ready to be developed. Diazo paper is developed and fixed by using pure ammonia fumes. The fumes will be quite strong and this is the only drawback to using the process with young children.

Pour about a cupful of ammonia into a plastic dishpan. Place a sheet of wire screen (with approximately $1/4$-inch holes) four-fifth of the way down into the pan so that the screen forms a platform right above the ammonia, thus allowing the ammonia fumes to pass through the wire mesh.

The paper to be developed is placed on the platform and a glass sheet larger than the pan is used to cover the top of the pan to prevent the fumes from leaking out. If you place the paper emulsion side up, you can watch the print developing through the glass. A few minutes for development is generally adequate. When dark contrasts in color appear on the print, it can be removed from the pan. No further steps are necessary.

On Diazo Chrome

A colored acetate film, Diazo Chrome can be processed in exactly the same way as the Diazo paper, though a longer time will be needed for exposure of the film by the sun's rays (about twice the time needed for paper). The result will be colored images on clear film. Prints on Diazo Chrome can be projected on the overhead projector or can be superimposed over other films to form a more complicated composition. The film is available in brown, yellow, red, blue, black, green, orange, and violet. Both Diazo paper and Diazo Chrome can be purchased from local blueprint companies.

On Construction Paper

Anyone who has ever worked with colored construction paper is most likely aware of the characteristic fading of the paper. For instance, after a bulletin board display has been taken down, shapes from the display still appear on the paper while the rest of the paper has faded out. Construction paper is not a photographic item in the usual sense but, since sunlight acts so strongly on it, the paper becomes a ready-made printing material and the idea is worth mentioning.

After objects have been placed in contact with construction paper, the background can be left to fade out to any degree desired, and the contact objects leave a sharp silhouette of bright color. The length of time the paper and objects must be left in the sunlight again depends on the strength of the sun. Fading will begin immediately, but the exact exposure time will depend on the background shade that is wanted. It might be a few hours or it might be several days before the desired effect is achieved. All colors are fugitive to sunlight, but the various shades of red and blue work quickly and produce the best contrast.

After several sheets of images have been created in different colors, the sheets can be cut up and put together again to create a multi-color composition. Any number of variations can grow out of the original idea.

In displaying the final prints, avoid placing them near a window. There is no way to permanently fix the images, but removing the paper from the sunlight will preserve the pictures for an extended length of time.

Photographic Paintings

This method of photography without a camera has been labeled photographic painting because light-sensitive paper is used almost like a canvas and photographic chemicals are used to paint the images. Rather than exposing selected parts of the paper (the areas not covered by the design objects) and then subjecting it to overall development, in photographic painting you give the paper an overall exposure (produced by the room-light as you work) and then develop selected parts of the paper by painting it with developer. The developed areas will be black with shades of gray. (They will be colored if toner is used.) Upon exposure to light, the paper darkens all over, but when the paper is fixed, the unpainted background will turn light again. Since no darkroom is required to make these paintings, this is an easy project to organize for small or large groups. This type of painting is excellent for just about every age range, with the exception of very young children.

The designs are painted directly on photographic paper with the developer solution or with color toners. Unusual and varied photographic effects are produced by using brushes, pens, string, and objects dipped in developer to create unique pictures. By using stop bath to stop the action of the developer at various stages, tonal values can also be controlled. This will cause some pictures to take on a moody and almost mystical atmosphere. Others will be clear and precise. In any case, the results are always surprising. The final pictures will resemble ink wash paintings, but they will be unmistakably photographic in character.

A variation of this technique is to paint the design on the exposed paper with fixer and to develop the entire print. The areas that have been treated with fixer will not be affected by the developer and will remain white while the background turns dark. This method also gives interesting photographic results.

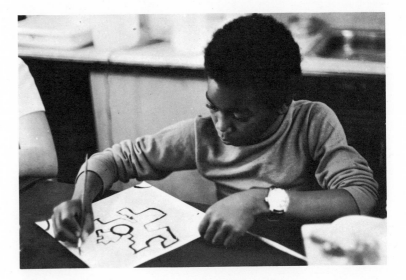

An art student paints directly on photographic paper with developer. This technique does not require a darkroom. (Mark Parnell, fifth grade.)

Painting with Black-and-White Developer

Mix the developer according to the instructions on the container and pour some of the solution into individual watercolor pans. (If a group is working together, use as many pans as needed for the individual members.) The developer should be mixed full strength or diluted 1:2. A weaker mixture (one part developer to six parts of water, for instance) used simultaneously with the stronger developer will increase the degree of light and dark effects that can be achieved while painting the design.

A full tray of stop bath and one of fixer will be needed. If a large group is working on the prints, having two or three trays of each solution would allow more people to use the trays at one time. A sink should be used to rinse the prints in cool, running water. (See page 54 for circulating rinse bath.) Have on hand a collection of assorted pens, brushes, cotton applicators, string, and odd-shaped objects that can be dipped into developer and pressed onto the paper to make an impression.

Most single- or double-weight contact or enlarging papers can be used for making photographic paintings. A glossy rather than a matte surface will give the prints more of the quality of a fine photograph.

The design should be painted directly on the exposed photographic paper with brushes or applicators dipped in the developer. Make sure that the sensitive side of the paper is face up. Photographic paper always curls towards the light-sensitive emulsion side, so it is easy to make sure, even in the darkroom, that the emulsion side is facing the light source for exposure.

It is best to begin working on *just one corner* of the paper. As the design is painted, the developer acts on the chemical surface and the painted areas begin to turn black. The intensity of tone depends on the strength of the solution and the length of time the solution is left on the paper.

Any number of exciting effects can be obtained by dipping string into the developer and dragging it over the surface of the

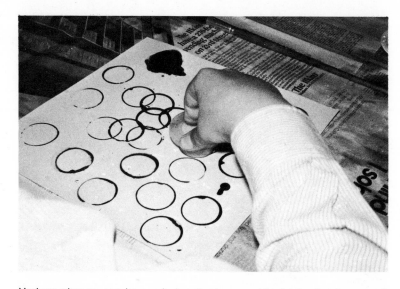

Various shapes can be made by dipping an object into developer and impressing the object on the paper.

Equipment

SHALLOW WATERCOLOR PANS
2 LARGE TRAYS
TONGS
GRADUATED MEASURING VAT
STORAGE BOTTLES FOR
 SOLUTIONS
SINK
BLOTTERS
ASSORTMENT OF BRUSHES, PENS,
 COTTON SWAB APPLICATORS,
 AND IMPRESSION-MAKING
 OBJECTS *(STRING, BOTTLE
 CAPS, AND OTHER OBJECTS
 THAT WOULD PRODUCE GOOD
 SHAPES OR LINES WHEN
 IMPRINTED)*

Supplies

CONTACT OR ENLARGING PAPER
DEVELOPER
STOP BATH
FIXER *(SEE SUPPLY CHART FOR
SPECIFIC BRANDS. ALL CHEMI-
CALS HERE AND IN THE FOL-
LOWING CHAPTERS ARE THE
STANDARD DEVELOPERS, STOP
BATHS, AND FIXERS USED FOR
PROCESSING BLACK-AND-
WHITE PRINTS. FILMS AS WELL
AS PAPERS MAY BE DEVELOPED
IN UNIVERSAL DEVELOPERS,
AND THEY USE THE SAME STOP
BATHS AND FIXERS. SEPARATE
DEVELOPERS FOR PAPER AND
FILM ARE ALSO AVAILABLE.)*

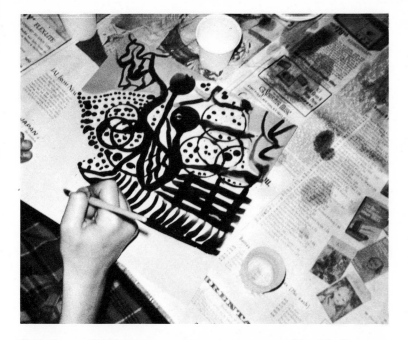

Dark lines, printed shapes, and gray tones are combined in the same picture by using pens, brushes, and objects dipped in developer.

paper, by stamping the paper with an assortment of objects that have been dipped in developer, or by washing a solution of developer over areas that have already been painted. With the last technique, a wide range of grays will emerge, producing a three-dimensional quality. In addition, drawing with pens dipped in developer will add a linear character to the design.

After the desired effect has been achieved, the worked corner should be dipped into the stop bath so the design will not develop any further. Be careful not to submerge the entire sheet. If you do, it will be difficult to work on the paper because the penetration of stop bath into the paper will slow down the developing action.

Remove the worked corner from the stop bath and paint the

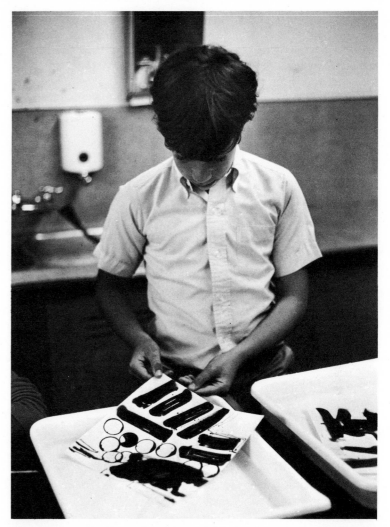

To control tonal values, the action of the developer is stopped at the appropriate time by dipping the print into stop bath. It is best to work each corner of the print separately. After working all four corners of the paper, fifth-grader Josh Drachman finishes by putting the last corner into the stop bath.

second corner. When it is finished, dip that corner into the bath, too. Do the same thing with the other two corners, working the design toward the center of the paper. When the painting is complete, set the entire sheet into the stop bath for 5 seconds. Remove the print and set it into the fixer for 10 minutes. Then place it in the rinse bath, where it should stay for one hour.

Finally, blot the prints and hang them up or lay them flat to dry.

Commercial photographic blotter books are good for blotting prints, but they are expensive. Regular school blotters, or even paper towels, work just as well. Remember to tap the surface of the prints. Don't rub them or the fuzz from the blotters will stick to the prints.

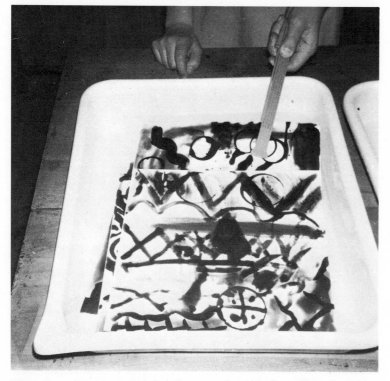

When the prints are completed, they are placed in fixer. They should be agitated occasionally so that they do not stick together.

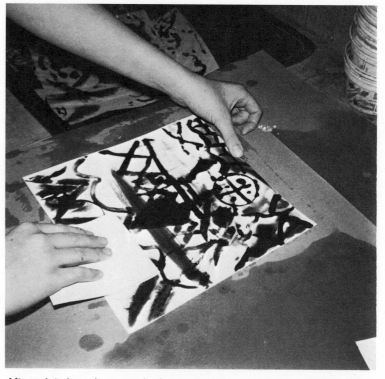

After prints have been washed, excess water can be removed by patting each print with a blotter or a paper towel.

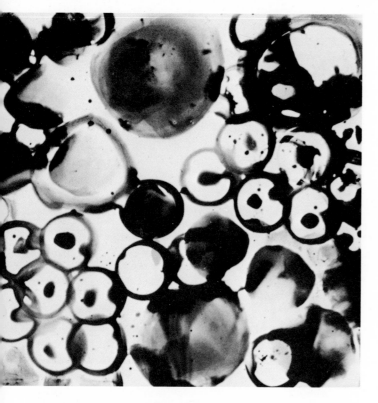

Above: Colored photographic painting done with Develochrome has some black content due to the presence of silver.

Right: In this photographic painting, the silver content has been bleached out.

33

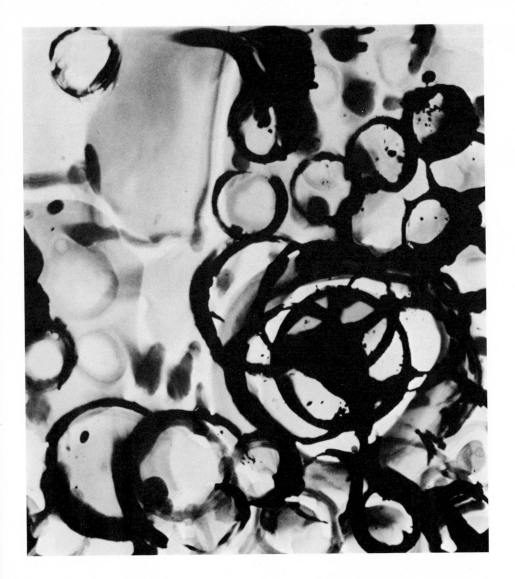

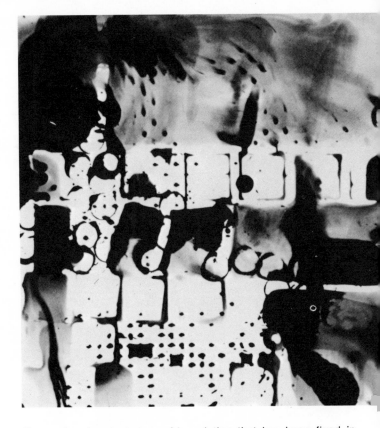

Above: A colored photographic painting that has been fixed in contaminated, but not exhausted, fixer retains only blue, black, and brown tones.

Left: To add black accents, standard black-and-white developer was painted on the paper along with the color toners. Unlike Develochrome, standard color toners do not leave any silver content in the print.

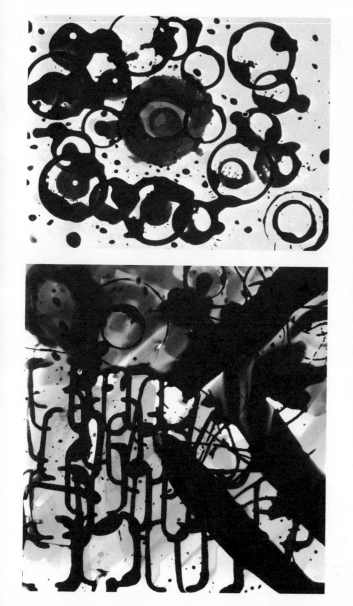

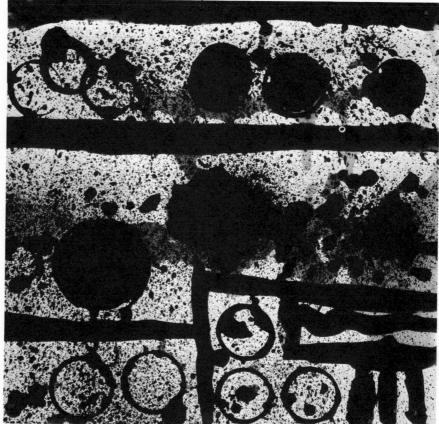

Above: Developing solution was spattered on the photographic painting. (By Laura Foti, fifth grade.)

Top left: Circular objects were dipped in developer and stamped onto exposed photographic paper. (By Cynthia Harris, fifth grade.)

Bottom left: By varying the strength of the developing solution, both light and dark tones are obtained. (Painted by Lori Salzman, fifth grade.)

35

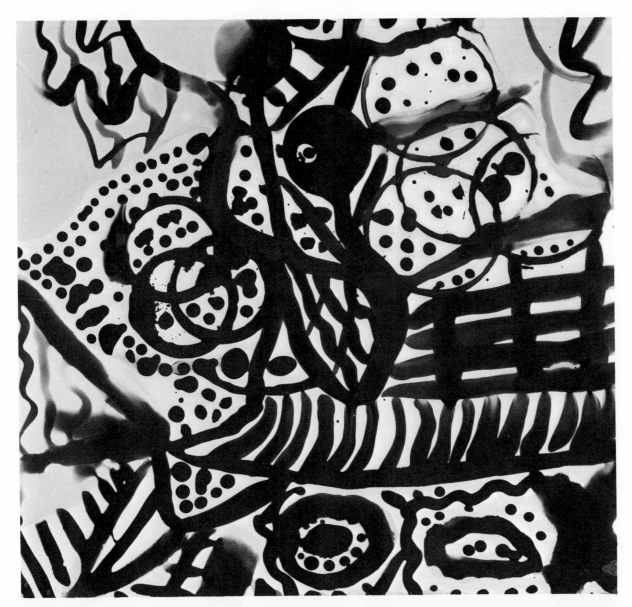

"The Glass Blower"

When the glass popped
We saw shining sparkles
Flying, floating in the air
Like small silver stars . . .
crystal particles.
Pieces floated high
and then they disappeared.

When the glass popped
I was stunned
I saw little raindrops
Floating up to the lights
A glass house exploded
And I saw shining stars
Little particles of silver confetti
Little mirrors reflecting light and people.

Left: Linear design was painted with developer and circular shapes were stamped onto the paper. (By Holly Pearl, sixth grade.)

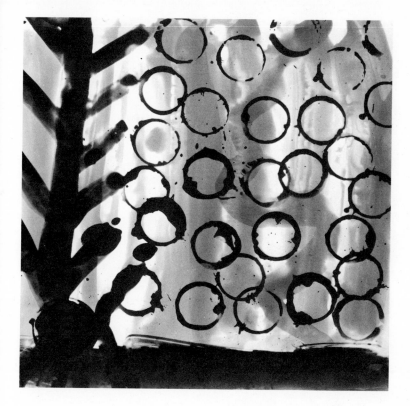

Painting with Fixer

When fixer is painted on exposed photographic paper, the appearance of the final prints will be exactly the opposite of those painted with developer solution. Fixer applied to the paper will cause white images to appear against a dark background.

For this technique you will need one tray of developer (used according to directions for standard development) and another tray to hold the fixer. Stop bath is not necessary. Use the same painting procedures as before, but dip the brushes and objects into the fixer instead of the developer. In this case, the entire sheet of photographic paper should be designed at one time because development cannot be stopped in stages as in painting with developer. Since the paper will curl when wet, it may be helpful to tape the corners down to a flat surface before proceeding to paint with the fixer.

After the paper has been painted with fixer, place it in developer until the desired degree of gray or black appears on the background of the print. The developer will eventually become contaminated from the fixer and turn dark but it can be used until the development time for a print becomes too lengthy or until the background color of the print become stained and foggy. You can prolong the life of the developer if you immerse the print briefly in clear water to wash off some of the fixer before you place it in the developer. However, the water will cause the fixer to spread somewhat and will result in intermediate grays blending with the black background. This effect can be visually striking.

After development, the entire print must be immersed in the tray of fixer for 10 minutes. It should then be placed in a clear water wash for one hour, after which it should be blotted and dried.

A variation of this technique produces antique-looking, brown images on a black background. First paint with fixer and place the print into the developer until the images appear white on the black background as before. Then remove the print from

Equipment

2 TRAYS
1 PAIR OF TONGS
GRADUATED MEASURING VAT
STORAGE BOTTLES
SINK
BLOTTERS
ASSORTMENT OF BRUSHES
 AND IMPRESSION MAKING
 OBJECTS

Supplies

CONTACT OR ENLARGING PAPER
DEVELOPER
FIXER

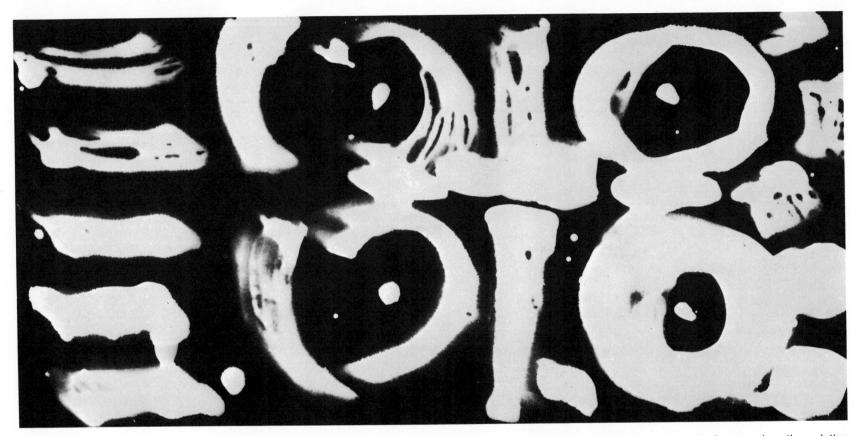

Black-and-white photographic painting with fixer used as the painting medium has white images on a black background.

the developer and let it stand for about half an hour or so before fixing. The developer will continue to act slowly on the partially fixed areas, causing the images that were previously white to turn to uneven and interesting shades of brown. When the desired shades are reached, fix the print thoroughly (for about 10 minutes), and wash and dry it as usual.

Painting with Color

Instead of painting the design on the paper with a black-and-white developer or with fixer, you can use various color toners, painted directly on the exposed photographic paper as before, to obtain multi-colored designs on a white background. Toners

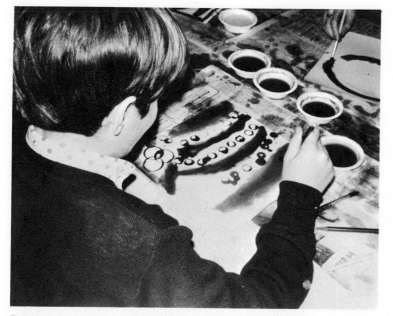

Painting the exposed photographic paper with color toners makes it possible to achieve multicolored images.

Equipment

SHALLOW WATERCOLOR PANS
(ONE FOR EACH COLOR)
2 LARGE TRAYS
2 PAIRS OF TONGS
GRADUATED MEASURING VAT
MEASURING SPOON
STIRRING DEVICE
STORAGE BOTTLES FOR
SOLUTIONS
RUBBER GLOVES OR DISPOSABLE
PLASTIC GLOVES (IF DESIRED)
SINK
ASSORTMENT OF BRUSHES, PENS,
COTTON SWAB APPLICATORS,
AND IMPRESSION-MAKING
OBJECTS

Supplies

GAF AIR MAP SPECIAL OR OTHER
ENLARGING OR CONTACT
PAPER
FR DEVELOCHROME DIRECT
TONING DEVELOPERS (FIXER
IS INCLUDED)
EDWAL COLOR TONERS (EXCEPT
BLUE)
KODAK SEPIA TONER
STANDARD BLACK-AND-WHITE
DEVELOPER (IF DESIRED)
KODAK EKTAPRINT C BLEACH
(IF DESIRED)
AGFA-GEVAERT BLEACH-FIX
(IF DESIRED)
SODIUM THIOSULFATE CRYSTALS
(IF DESIRED)

are chemical solutions that result in colored images — either by forming a dye image along with a silver image during development (direct coupling toner) or by converting a previously developed silver image to a dye image (standard toner). In photographic painting, there is no prior development, but standard toners in concentrate will color the paper. FR Develochrome is a direct coupling toner which will develop the exposed paper as well as tone it. When working with color toners, it is sometimes a good idea to wear rubber gloves, because, occasionally, people tend to be allergic to the coloring agent.

The FR toners work well on most contact and enlarging papers. The standard toners work best on GAF Air Map Special paper, which has a water-resistant backing. On other papers, standard colors fade out to varying degrees after fixing and washing. This can result in muted and pastel tones. If brighter tones are desired with the standard colors, the paper can be fixed first (this is not necessary with the Air Map Special) and the standard toners can be painted on the damp paper. However, if FR toners or black-and-white developers are to be used along with the standard toners, they must be painted on before the paper is fixed. The standard colors can then be added to the fixed painting. Do not refix the painting before washing it. On the GAF Air Map Special, the various toners and the developer can be used simultaneously, directly on the exposed paper, and will give consistently bright colors.

The Develochrome has a good selection of bright colors (blue, yellow, green, sepia, and red); Edwal color toners and Kodak sepia toner, which are standard color toners, provide different color effects and, when they are used with FR toners, many additional color combinations can be achieved. Develo-

chrome is available in small packages; each makes 12 ounces of toner and includes a separate package of color fixer. The same fixer can be used to fix photographic paintings made with standard toner. A standard black-and-white acid fixer is not used in making color prints because the acid in the fixer would destroy the dyes. You can make your own fixer for color prints (5 tablespoons of thiosulfate crystals in 32 ounces of water).

If a large group is working at the same time, mix the fixers from all the FR color packets in one or two large trays. The makeup of the FR fixers is the same for all colors. Then, mix each color individually in separate plastic bottles, according to the directions that come with the package. Label each bottle and use each exclusively for the color you originally mix in it. Edwal toners come with their own bottles. Remember that you do not dilute the concentrated solutions of Edwal color toners for direct painting.

Pour some color toner from each bottle into individual watercolor pans. Have at least one brush and separate tools on hand for each color. Dipping a brush, pen, or printing object from color to color destroys the purity of the colors.

When making colored photographic paintings, it is best to work on an entire sheet of paper (contrary to the black-and-white method). The paper will curl, so the corners should be taped down onto a flat working surface. The color will become especially strong if each part of the design is painted with ample amounts of toner. The toner should remain on the surface of the paper until it becomes intense in color.

After completing the design, dip the paper briefly into a tray of clear water. This step is not necessary, but it washes off excess developer (Develochrome) and prolongs the life of the color fixer. Fix the prints for 3 to 5 minutes and wash in clear water for another 5 to 15 minutes. Don't overwash. If the colors begin to fade, shorten the wash time. Blot off the excess water and allow the prints to dry.

The Develochrome colors will contain some black due to the presence of silver (see illustration on page **33**). If bleaching out the silver to obtain a pure color image is desired (see example on page **33**), Agfa-Gevaert puts out a solution called Bleach-Fix which can be used *in place of* the packaged color fixer (it bleaches and fixes the prints in one step). Kodak Ektaprint C Bleach can also be used, or a bleach could be made from 16 ounces of water, 4 ounces of sodium thiosulfate, and $1/2$ ounce of potassium ferricyanide. These bleaches can be used with all the Develochrome toners. If you use a *non-fixing* bleach (Ektaprint C or the thiosulfate solution), the print must first be placed in the color fixer for 3 to 5 minutes. Then the print should be dipped into the bleach until the desired amount of black disappears. Wash the print for 5 to 15 minutes; dry as before.

If you prefer to add black to the print rather than eliminate it, a standard black-and-white paper developer, such as FR paper developer or Kodak Dektol can be painted on the picture along with the color toners. This introduces strong blacks as an accent to the color and is very effective (page **34**).

There are several drawbacks to using the standard developer, however. As the finished prints are placed in the color fixer, the fixer will slowly become contaminated from the standard developer, and the colors on subsequent prints will begin to wash out of the picture. Eventually, only the blue and brown tones will survive along with the black; but this, too, can result in a rich composition (page **34**). If a washed-out effect is not desired, fresh fixer will have to be made by dissolving 5 tablespoons of thiosulfate crystals in 32 ounces of water.

When using the black-and-white developer along with the toners, the colors can be brightened, after the print has been fixed in the color fixer for 3 to 5 minutes, by dipping the print in the bleach for a second or so until the desired color tones appear. The print must then be set into the clear water bath immediately to stop the action of the bleach. These prints cannot be placed into bleach for an extended period of time because the blacks will wash out from the picture entirely. After fixing and bleaching, these prints are also washed for 15 minutes, blotted, and dried.

 # The Makeshift Darkroom

So far, our handling of photographic papers has not called for the use of darkroom procedures. The paper used for sun prints could be safely exposed to subdued light long enough to compose the objects, and the paper did not require chemical development. In photographic painting, the contact and enlarging papers were deliberately given an overall exposure to light so that images could be developed by the application of chemicals to selective areas of the paper. However, when the sunprint technique of arranging objects on the paper for selective exposure is employed with highly sensitive contact or enlarging papers, the entire procedure — from composition, exposure, and development to fixing — must be done in the darkroom under safelight conditions, to make sure only the desired parts of the paper are exposed to light.

Roomlight handling papers do not have to be processed in darkness but a similar physical setup of the work area is used to take the print through each step, from composition to washing and drying. In preparation for darkroom and roomlight techniques, this chapter will discuss how to convert a regular room into an adequate darkroom.

One requirement is that the room have an electrical outlet or two for plugging in safelights and white lights. The room should have a sink in which to rinse prints, but this could conceivably be in another room.

To block out all other light, window shades should be pulled, or some dark material should be placed over the windows. Any light entering from the edges of either shades or doors must also be blocked out. Heavy, brown wrapping paper is good for this purpose. Naturally, it is easier to block out the light at night; but, even then, the shades must be drawn to prevent any unexpected light from entering. Keep in mind that excess light of any kind will start the photochemical process and fog sensitive photographic paper, causing undesirable, dense tones when the paper is developed.

If just one or two persons will be working in the darkroom, the size of the room should be no smaller than 5 by 6 feet and no larger than 10 by 12 feet. It is possible, however, to convert a large classroom into a darkroom accommodating many persons. In such a case, it is a good idea to have several setups of trays, chemicals, and lights. The same sink can be used for the entire group.

In preparing a darkroom, equipment and materials should be set up so that the working arrangement is both efficient and convenient. Trays of chemicals to be used should be placed in a row to allow for the smooth transfer of paper or film from one tray to the other during development, stopping, and fixing. These trays should be set up on a counter or table near the sink. Spilling will no doubt occur, so plastic or paper should be placed under the trays unless the counter top is made of a wipe-off, non-staining material. Keep paper towels handy for wiping water and chemicals off the table, floor, and hands. This then will be considered the "wet area" of the darkroom.

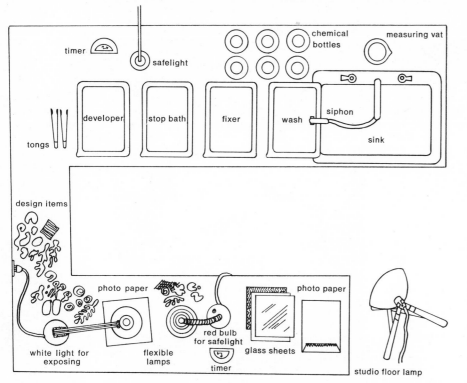

timer · safelight · chemical bottles · measuring vat

tongs · developer · stop bath · fixer · wash · siphon · sink

design items · photo paper · photo paper · red bulb for safelight · glass sheets · studio floor lamp

white light for exposing · flexible lamps · timer

Arrangement for a makeshift darkroom. Note that "wet area," including sink and trays of chemicals, is separated from "dry area," where paper is exposed.

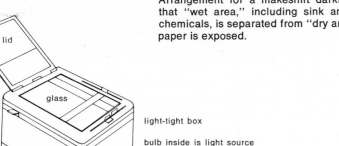

lid · glass · light-tight box · bulb inside is light source

Contact printer.

The "dry area" of the darkroom should be situated some distance away from the sink and the chemical trays. Here the prints will be arranged, exposed, and otherwise worked on. One white light for exposing the paper and one safelight should be set up over the work surface on which the paper will rest.

The safelight must be on while the arrangement of objects is composed, and the white light will be turned on only for exposure, so it is necessary to have both lights ready for use. The safelight should be positioned at least 4 feet away from the paper so there is no danger that the light will fog the paper. The white light can be placed from 2 to 4 feet above the paper depending on desired exposure. A second white light should be installed if there is no overhead light that can be turned on and off when printing (including developing and fixing) is not in progress.

For safelights, a 25 watt red or a 60 watt yellow bulb is usually recommended for working on paper, and a G.E. 25 watt ruby bulb (or sometimes a yellow light) can be used for working on film. One safelight should also be placed over the developer tray so the latent image can be viewed as it emerges in the developing solution.

Development time does not have to be checked but exposure time does. A standard kitchen timer or a clock with a second hand will suffice.

Another piece of photographic equipment that is sometimes useful in the darkroom is a contact printer. This is a light-tight box with its own light source, which is covered by glass. Shapes of paper can be placed on the glass (or a negative can be placed there emulsion side up) with a piece of contact paper on top (its emulsion towards the light source). The box is then closed and the light is turned on to expose the paper. Since the box will accommodate only two-dimensional materials, its experimental usefulness for making photograms is limited; but it is a helpful addition to the darkroom nevertheless.

An ordinary sheet of glass or a commercial contact printing frame can also be used to hold two-dimensional objects, or a

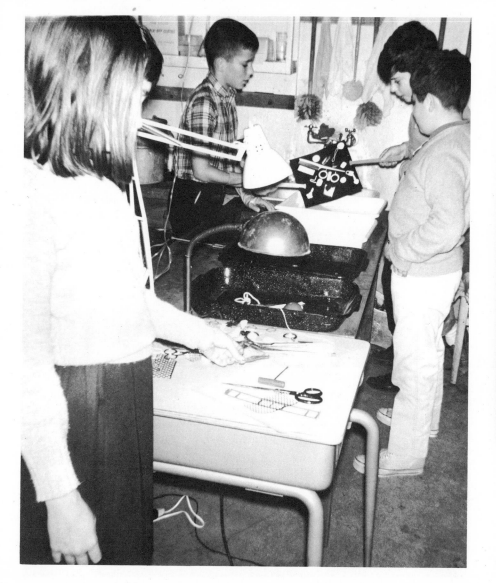

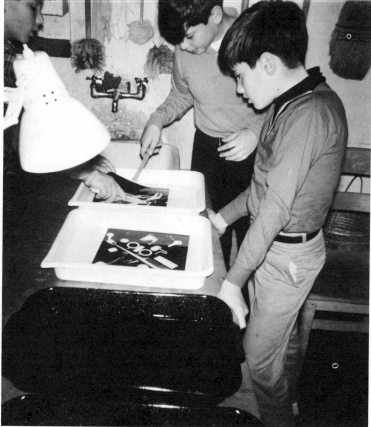

Above: Processing trays are arranged for easy transfer of prints from chemical to chemical. Tray nearest the sink is fixer, which is used last. (Students here are Mickey Goldfine, Joe Sablow, and Jeff Potter.)

Left: A custodian's closet was converted into a darkroom for students' use. Printing area is in foreground; flexible lamp on the table is for exposing print, while architect's lamp holds safelight bulb. In the wet area, a print is being inspected as it is taken out of the fixer. (Sixth-graders here are Karen Kaliner, Mickey Goldfine, Joe Sablow, and Jim Joseph.)

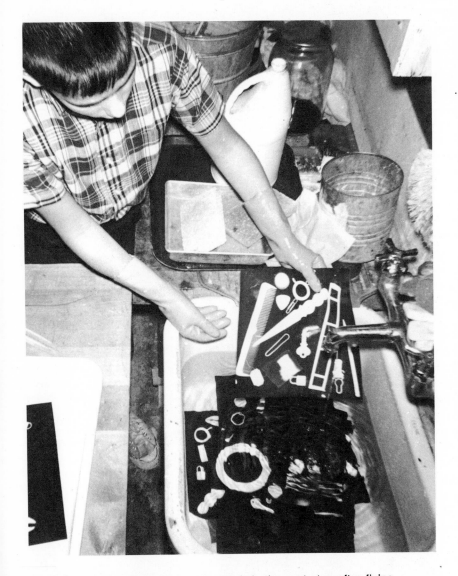

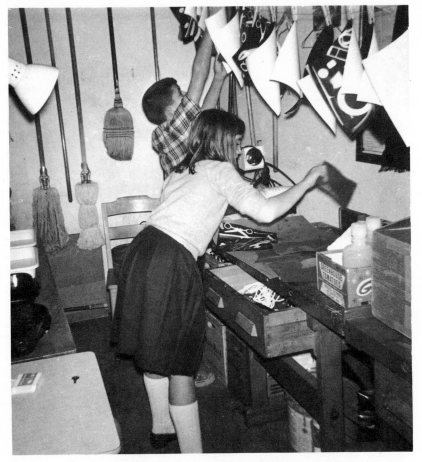

After the wash, prints are blotted and hung up to dry. (Mickey Goldfine and Karen Kaliner.)

Placing the print into a clear water wash is the next step after fixing. (Student is Mickey Goldfine.)

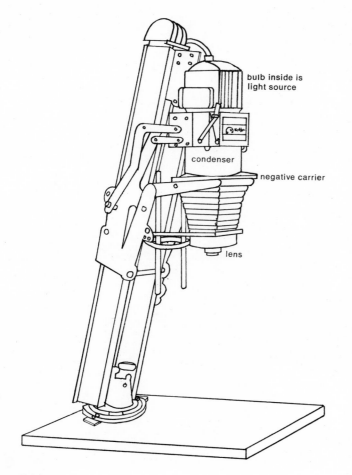

bulb inside is
light source

condenser

negative carrier

lens

Enlarger.

negative, flat against the photographic paper while the arrangement is exposed to a separate light source.

It is entirely possible to compose and develop prints of excellent quality in a makeshift darkroom; but a well-equipped darkroom is naturally more convenient and gives the artist the added advantage of working with an enlarger. The enlarger (normally used for projecting an enlarged negative image onto the photographic paper by means of an enclosed bulb, a condenser, and a lens) makes some techniques of printing possible that a regular lamp cannot — such as selecting one area of a photogram made on film for printing an enlarged version on paper. Objects can be placed either in the negative carrier of the enlarger or directly on the paper, or both, for exposure. In addition, the aperture in the enlarger's lens can be regulated, controlling the amount of light transmitted to the paper. One limitation of the enlarger is that it is a vertical light source and cannot be mounted at an angle for unusual exposures. The light stands and lamps recommended later in this chapter for use with bare bulbs can be swiveled.

The description here of equipment and of the darkroom setup can serve as a guide to what you will need or find useful for making photograms. More detailed information on equipment can be obtained from photographic supply manufacturers and from local photography stores. The teacher or amateur photographer who is thinking of installing his own facilities can also get, on request, excellent pamphlets on how to set up a darkroom from the Eastman Kodak Company in Rochester, New York.

The same equipment and the same division of the work room into "wet" and "dry" areas is used for printing and processing roomlight handling papers, except that it is not necessary to block out all light from the windows and doors or to use safelights.

Lighting Equipment

Only limited lighting equipment is needed for exposing prints but a few tips on stands, reflectors, and table lights will help you choose the most suitable items, according to the item's availability and price, and the particular photographic process it is to be used for.

Some of the faster darkroom films, for instance, require a dim light source 6 or 7 feet above the film. For that situation, a lightweight aluminum, telescopic stand is ideal because it can be raised or lowered according to need. These stands come in different heights, but one that can be raised to 8 feet will cover all distance requirements. The telescopic stand is also good for holding safelights where mobility is desired. The stand can be moved around the entire room and placed in various positions.

A swiveling floor stand with a boom arm is also useful for raising and lowering the light source. The arm allows the light to be shifted far over the print for exposure.

Sockets to be attached to light stands come with their own electrical cord and a spring clamp for fastening. Metal reflectors, which direct the light from a bare bulb, can be screwed onto the sockets. The sockets will take photofloods as well as standard-size bulbs. Mushroom-shaped photofloods (reflector-type bulbs) are silvered to act as their own reflectors.

Two types of table lamps are good for making photograms. The first is a flexible metal lamp with a reflector shade. This lamp can be swiveled to transmit light from almost any direction. The second is an architect's lamp with a long extension arm. This also can be tilted to different angles, and raised or lowered. Safelights or white light bulbs can be used with these lamps.

The most important feature of all these lamps is that they are movable and can be adjusted for temporary and makeshift situations.

Reflector shade.

Photoflood light bulb.

Telescopic light stand.

Light stand with a boom arm.

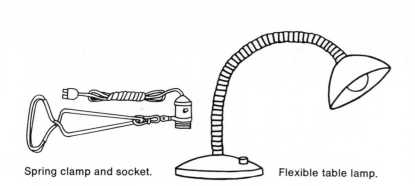

Spring clamp and socket. Flexible table lamp.

Architect's lamp.

Storage and Care of Photographic Equipment

After each session, whether you have printed in roomlight or under darkroom conditions, the photographic equipment should be cleaned and stored in order to make it easier to prepare for the next work period. Before the enlarger is stored, tie a plastic bag over the head so the lens and negative carrier will be kept free of dust.

Before they are stored, all the trays should be cleaned thoroughly after each session, using a mild soap and water solution; at the least, they should be rinsed well with water. The developer tray might become quite dark after prolonged usage and a tray cleaner can be purchased that will take the stains out instantly. If you cannot obtain commercial tray cleaner, you can make your own. The following two solutions will clean trays when they are used together and they can be made of chemicals purchased from a chemical firm or sometimes from the local drug store. Mix the chemicals according to the following formulas. (Always add acid to water, not vice versa.)

Solution 1

Water	30 ounces
Potassium permanganate	75 grams
Sulfuric acid, C.P.	3 drams

Solution 2

| Water | 30 ounces |
| Sodium bisulfite | 1/2 ounce |

Pour solution 1 into the tray and allow it to stand for a few minutes; then rinse the tray with water. Pour solution 2 into the tray, swish the solution around in the tray, and then wash the tray thoroughly. It is best to wear rubber gloves while cleaning the trays because tray cleaner stains the hands.

Make sure that the containers for paper are taped tightly shut with masking tape, and store the paper in a drawer or cabinet so no light or air can get to it. Storage in a cool place helps prolong the life of paper and film, so you may want to store these supplies in your refrigerator.

Finally, try to keep all the equipment and materials in one place so it will be easy to set up the work space next time it is to be used.

6 Printing in the Darkroom

Black-and-White Prints on Paper

After the darkroom has been arranged, the chemicals have been mixed, and the sink has been cleared for washing the prints, the next thing to consider is the designing and exposing of the print.

Designing prints in the darkroom is similar to designing sun prints. Objects placed on the paper will, according to their degree of opacity, prevent light from reaching the areas they cover, and the resulting images after chemical development will be white, or white with gray tones, against a black background. Many sophisticated variations of this simple technique can be devised in the darkroom, using either a bare bulb, an enlarger, or a contact printer as the light source.

The bare bulb provides the least expensive, and many times the most convenient, type of light for exposure. Using one of the recommended lamps or sockets, you can direct the light from almost any angle to throw interesting shadows from the design objects onto the paper. The light can also be directed through wire mesh or textured glass held in front of the bulb.

The enlarger can be used to project images of objects placed in the negative carrier's space, either as a separate

Equipment

3 TRAYS
2 PAIRS OF TONGS *(USE SEPA-RATE TONGS FOR REMOVING PRINTS FROM STOP BATH AND FIXER)*
GRADUATED MEASURING VAT
TIMER
STORAGE BOTTLES FOR SOLUTIONS
BLOTTERS
SINK OR TRAY FOR RINSING PRINTS
PIECE OF GLASS LARGER THAN THE PAPER BEING USED *(IF DESIRED)*
SAFELIGHTS *(25 WATT RED OR 60 WATT YELLOW BULBS)*

LIGHT STANDS AND SOCKETS OR DESK LAMPS
WHITE LIGHT *(ENLARGER, CONTACT PRINTER, OR 10 OR 100 WATT LIGHT BULB)*
ASSORTMENT OF OBJECTS TO USE IN MAKING DESIGNS

Supplies

ENLARGING OR CONTACT PAPER
DEVELOPER
STOP BATH
FIXER

Opposite page:
Pale images beneath the hand were obtained by exposing the arranged objects first, then positioning the hand and giving the new arrangement additional exposure. (Dana Horowitz, fifth grade.)

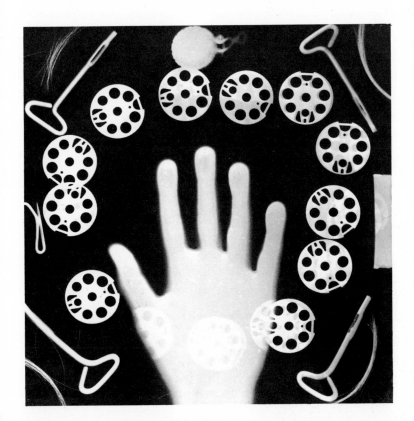

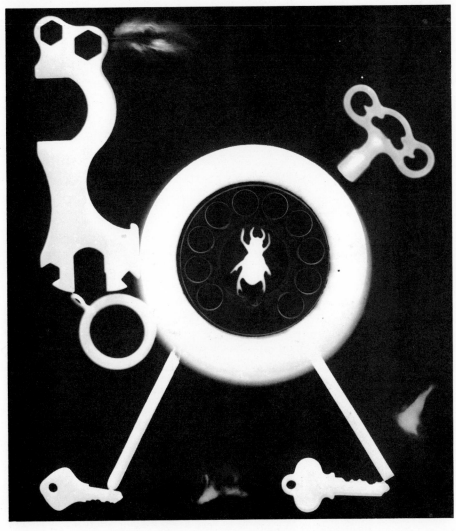

Combining a series of unlikely objects, a student composed this X-ray view of an imaginary animal with a spider inside it. (Jim Joseph, sixth grade.)

49

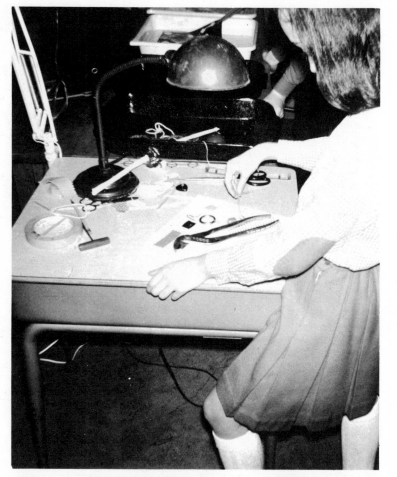

While the objects are being arranged on contact or enlarging paper, the room must be dark, illuminated only by a safelight. The easiest light source to use for exposing the print is a bare bulb (used here in a flexible table lamp) placed at least 2 feet above the paper. Exposure time and wattage depend on the paper used.

composition or in conjunction with objects placed directly on the paper; to project the images of a photographic negative and obtain a positive print; or to project images drawn or painted on glass or film (clichés-verres — see pages **60** to **63**). The contact printer (or a simple frame) can be used to print negative paper photograms, negative films, and forms of clichés-verres. The same principles of exposure and development apply to all these variations. Any density, whether in a three-dimensional object or in a two-dimensional negative, will keep light from the paper in varying degrees.

The assortment of objects can include almost anything. You will get some idea of what objects to use from the photograms shown throughout this book. Before you begin to make your print in the darkroom, make sure you have your objects for it on hand. You cannot turn on the light in the midst of composing the print to find something you have forgotten. The light source is turned on only for the time it takes to make the exposure, and it is turned off immediately afterward.

With only the safelight on, remove the paper needed for one exposure and then make certain the package is closed to protect the remaining paper from the exposure light. Place the paper, emulsion side up, on a table. A piece of glass can be placed over the paper to keep it flat and objects can be arranged on top of the glass for even exposure. The glass is helpful but not necessary, and objects can be placed on the paper without the glass. Even though the paper will curl slightly, the print will usually still be successful.

The amount of exposure you should give the composition will vary according to the type of paper, the strength of the light source, and the distance of the light source from the paper. Basically, your exposure will be aimed at obtaining the desired degrees of gray tones in the images. This will call for some experimentation through trial and error, but some guidelines

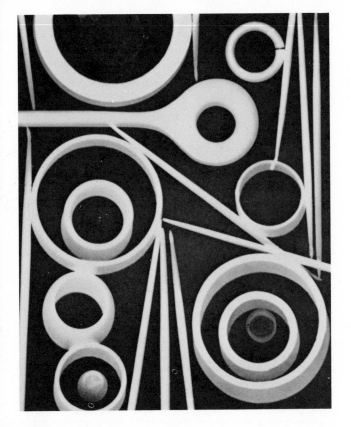

Above: A print made in the darkroom and processed directly in FR Develochrome has a darkly colored background and lightly colored images.

Right: Clichés-verres made from the same glass plate used for Figure 2 on page 61 was printed in black and white. Food coloring was applied by hand to tone areas of the print.

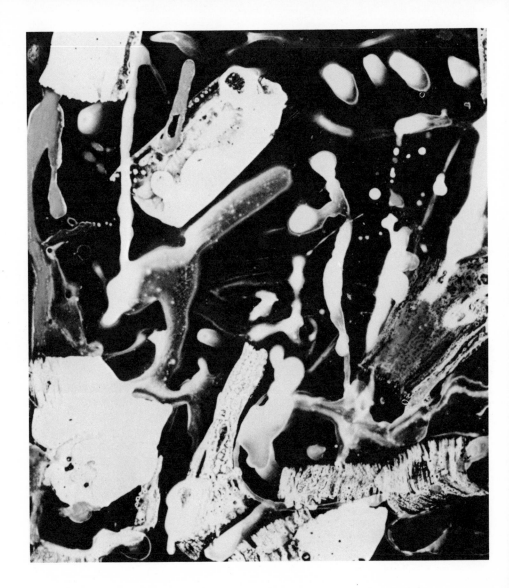

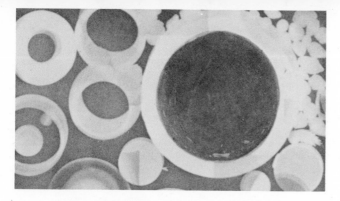

Above: A photogram on Du Pont Cronapaque film was processed in FR Develochrome (blue) after one circle had been masked with rubber cement. When the print was dry, the mask was removed and a red standard toner was added to the print by hand.

Right: Compare this photogram, developed in blue FR Develochrome, with the black-and-white version (page 72), which was also made on Adlux film.

Right: This darkroom print on paper was partially masked with rubber cement immediately after exposure, then processed in Develochrome (blue). The mask was then removed and the print was dipped in standard color toner (dark red).

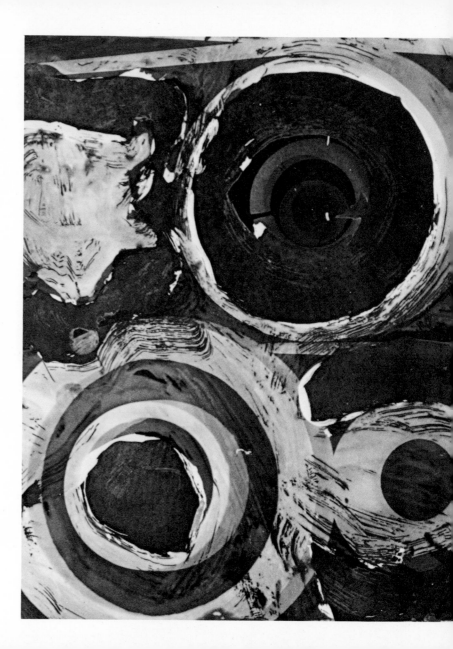

can be given. For contact paper, use a 100 watt bulb at a height of 2 feet and expose for about 5 seconds. If a lamp is positioned closer than 2 feet, a hot spot may develop. For enlarging paper, use a 10 watt bulb placed 3 feet above the paper and expose for approximately 2 seconds. You can also use a 25 watt bulb if you increase the height and shorten the exposure time.

If an enlarger is used as the light source, the amount of light can be increased or decreased by adjusting the opening in the lens to different sizes (f-stops). As you decrease the light, you must increase the exposure time. After you have obtained some correct exposures by trial and error, you will be able to tell approximately what exposure time to use with each f-stop. It is preferable to use enlarging paper instead of contact paper with the enlarger.

After exposure is completed, the print should be placed, face up, into the developer, under the illumination of the safe-light so the images can be closely watched as they appear on the surface of the paper. Hold the print by one corner with tongs and agitate it slightly so the developer can wash over it. There is no exact time limit for the development of photograms as there is when developing a conventional photograph. Because of the various degrees of translucency of some of the design objects that may have been used, development time must be calculated completely by eye. This may take some practice because the print appears darker when viewed under the safe-light than it actually is. At the same time, if the print remains in the developer too long, the subtle shades of the design will disappear.

When the correct shades of light and dark appear on the print, remove it from the developer immediately and place it into the stop bath for about 5 seconds. Then, using a second pair of tongs, lift the print out of the stop bath, and let the excess solution drip into the stop bath tray. Place the print in the fixer, where it should stay for about 10 minutes. Once the print has been in the fixer for 5 minutes, roomlights can be turned on without affecting the print.

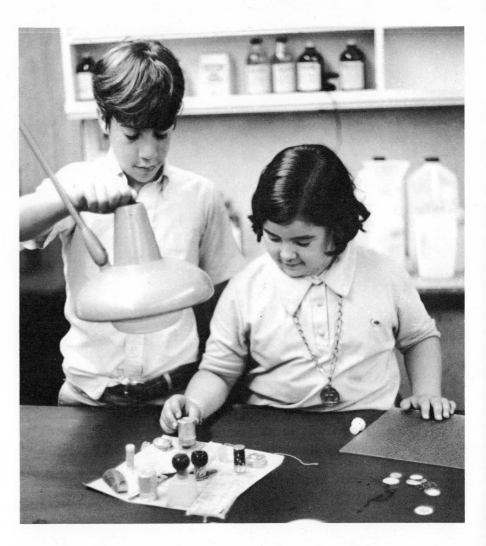

Fifth-graders Josh Drachman and Diane Wake expose an arrangement to light.

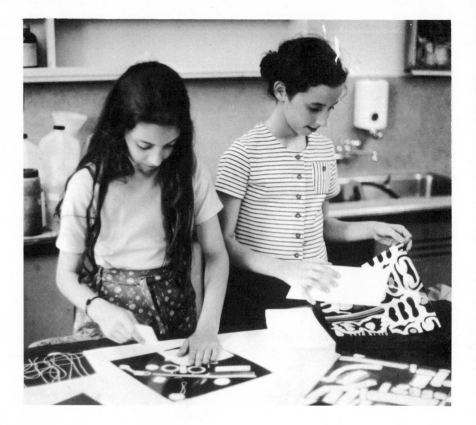

Finally, the picture should be washed in cool, running water for an hour. Ideally, this requires a sink, a tray to hold the prints and a siphon to draw off the contaminated water. The tray is placed in the sink or on a counter and water is allowed to run into it continuously from a faucet, while the siphon empties the water from the tray into the sink. A good substitute method of circulating the water, if you do not have a siphon, is to place a glass tumbler upside down directly under the faucet so the water can run over it into the tray and overflow into the sink. If the sink is partially stopped so that it retains some water, you can put the prints directly into the sink and eliminate the tray. If no sink is available, you can wash prints in a tray of water, but you will have to replace the water five or six times during the rinse time. A photographic washing aid (see Supply Charts) can be used to cut down the wash time. The prints should then be blotted and dried.

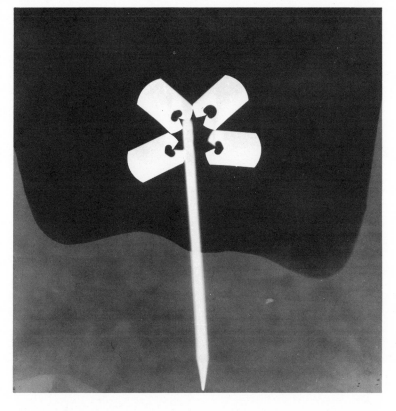

The top section of the exposed photogram was placed in the developing solution first, creating two tones in the background of the print. (Carolyn Revelli, fifth grade.)

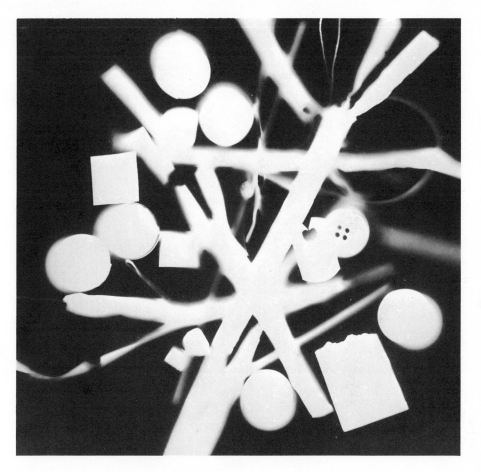

Shifting objects slightly during exposure resulted in shadowy outlines on some shapes. (Photogram by Terry Stamm, fifth grade.)

Opposite page: (Left) Rinsing the prints should be done in circulating water. Ideally, a commercial siphon is used to draw off the contaminated water while fresh water runs in. However, substitute methods can be used. *(Right)* Hand blotters are used to remove excess water before prints are hung up to dry. (Fifth-graders Patti Levey and Lori Salzman.)

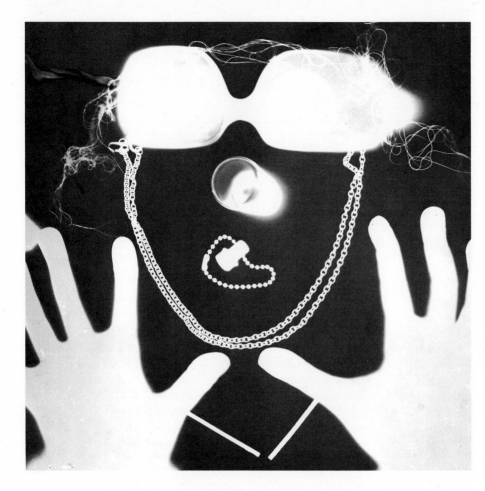

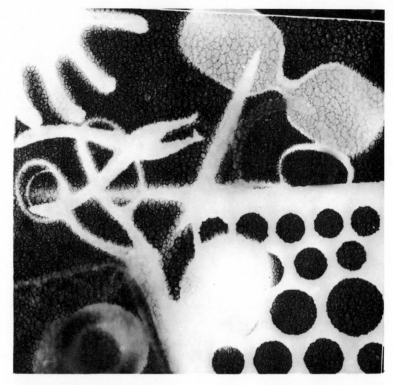

Textured glass was placed over the objects to create a translucent, shadowy atmosphere on the print. (Lyle Pfeffer, fifth grade.)

Photogram incorporates the artist's own hands in the overall picture (by Pam Fields, fifth grade).

Color Prints on Paper

Color prints can be made with either standard color toners or direct coupling toners. Because the two types of toners differ in their chemical actions, you must use a separate procedure for each one. This was not necessary when the toners were used for photographic painting because the standard toners were allowed to form dye images wherever they were applied. In the darkroom, however, the standard toners are used to color images already produced by the objects in your design. The print must therefore be developed to finality with black-and-white developer and fixed before toning. This leaves white images which will take on the color of the toner. (If the print were left in the toner for an extended time, the toner would also color the background by reacting with the silver there as it does in photographic prints.)

Prior development and fixing is not necessary when you use direct coupling toners (Develochrome toners), which develop the images while coloring them. The background of the print, which has received the greatest amount of exposure and which develops most fully, will become darker in color than the less developed images. After this one-step development and toning, the prints are fixed in the special color fixer that comes with each package of toner. Neither a stop bath or regular black-and-white fixer is used with direct coupling toners. Do not use trays for color chemicals interchangeably with trays used for black-and-white chemicals. Keep them separate and have individual trays for each color.

DIRECT COUPLING TONERS Mix the colors and the packages of fixers according to the directions that come with the Develochrome. Pour each color solution into a separate tray. The fixer can be mixed together in one tray if desired. People who are allergic to color toners should wear rubber gloves.

After the design has been arranged on the paper and exposed briefly to light, the paper should be placed in the color

Additional Equipment

MEASURING SPOONS
3 OR MORE ADDITIONAL TRAYS *(TO HOLD COLOR TONERS OR VEGETABLE COLORS, COLOR FIXER, AND BLEACH; TRAYS USED FOR BLACK-AND-WHITE CHEMICALS MUST NEVER BE USED FOR COLOR CHEMICALS AND EACH COLOR TONER SHOULD HAVE ITS OWN TRAY)*
RUBBER GLOVES *(IF DESIRED)*
CAMEL'S-HAIR BRUSH

Additional Supplies

EDWAL COLOR TONERS *(GREEN, RED, YELLOW, OR BROWN)*
FR DEVELOCHROME *(RED, BLUE, SEPIA, GREEN, YELLOW)*
KODAK SEPIA TONER
AGFA-GEVAERT BLEACH-FIX *(IF DESIRED)*
VEGETABLE DYES
TRANSPARENT INKS
KODAK RETOUCH DYES
RUBBER CEMENT

toner. Hold one corner of the paper with tongs so it can be agitated in the toner. The background of the print will take on the color of the toner that it is placed in, leaving white or lightly colored images where there has been little or no exposure (see page 51). After removing the print from one color, you might even set it into a second color for interesting color changes.

After toning, rinse the print briefly, then fix it for 3 to 5 minutes in the Develochrome color fixer. (The print could also be bleached before or during the fixing, using the same methods described for bleaching colored photographic paintings.) Finally, wash the print for 10 minutes before blotting and drying it.

When you have toned a few prints, begin to try more unusual techniques. For instance, try masking out random sections of the print with rubber cement immediately after exposure. Let the cement dry and place the print in Develochrome. Remove the print when the background reaches the desired intensity, blot off the excess solution, and remove the rubber cement. When the print is partially dry, apply new cement to the areas that have already been colored by the Develochrome, leaving the previously masked spaces blank. Again, let the cement dry,

57

and place the print in a *standard* toner of another color. After toning, remove the rubber cement, fix the print for 5 minutes in color fixer, and wash it for 10 minutes. The result will be a multi-colored print.

STANDARD TONERS Edwal standard color toners are easy to handle and provide vivid colors. These colors stain, so be careful when using them. Here again, rubber gloves should be worn by those people allergic to the coloring agent.

Mix the toners, dilute them according to directions on the package, and place them in separate trays. After arranging the composition on the paper and exposing it, develop the print to finality in standard black-and-white developer. Use a stop bath and then fix the print in standard fixer. Wash the print in clear water for a short time to remove the hypo (fixer) and then place the print in the color toner for a few minutes until the images take on the desired intensity of color. The background will be black because of its development in the standard developer. However, if the print remains in the toner, the silver in the background will eventually be converted to a dye image and may turn chalky if toned too long. The longer the print has been washed before toning, the more likely it is that the blacks will turn chalky in tone.

A toned print can be placed into several different colors in successive steps for varied color combinations. Masking-out procedures and other experiments could also be tried with standard toners.

The prints do not have to be fixed after toning and should be put directly into a running wash for about 10 minutes. Make sure the water does not run directly on the prints. After they are removed from the bath, they should be blotted and dried.

COLOR TONING WITH VEGETABLE COLORS Vegetable coloring is a good agent when a single color image is wanted. It is inexpensive, the colors are vivid, and the solution is easy to

prepare. Just mix about a tablespoon of vegetable coloring to 16 ounces of water in a tray. The mixture can be made weaker or stronger depending on the strength of the color desired.

Expose, develop, stop, and fix the print as usual. Then dip the print briefly into clear water to take off the excess hypo. Place the print into the vegetable coloring solution until the desired intensity of color is reached. The print can also be placed into trays of other vegetable colors for blends. It is best to tone the print a little darker than the intended shade because the print must be placed into a clear water bath for an hour after toning and some of the excess color will wash out of the print. The black background will tone to some degree along with the images. Finally, blot the prints and let them dry.

HAND APPLICATION OF COLOR The hand application of color to finished black-and-white prints, or to partially toned

Opposite page: Print was first developed and fixed in black-and-white chemicals, then color toned in standard red toner.

Right: For the original photogram, a sea fern was placed in the negative carrier and projected onto single-weight paper.

Far right: The original photogram was then contact printed on Brovira #2 double-weight paper for a positive print. The light source for contact printing was an enlarger at f/5.6; exposure was 10 seconds.

color prints, can be very effective. Vegetable colors or standard toners applied with a camel's hair brush work very well (see page 70). Kodak retouch dyes are available in a variety of colors and can be applied with a soft brush or with a cotton swab. Transparent inks are also useful for this purpose.

If rubber cement has been used to mask out a section of a color-toned print, the space left by the rubber cement can be colored by hand once the print has dried and the cement has been removed (page 52). Any of the coloring agents mentioned in the preceding paragraph will produce a photographic effect and will not appear to have been painted on to any great degree.

Contact Prints

As mentioned at the beginning of the chapter, the darkroom can be utilized to make positive prints of your photograms by contact printing the original, negative version. If you do not have a contact printer, you can use the following procedure.

Place a sheet of photographic paper, emulsion side up, on a flat surface. Use only the safelight for illumination. Set the photogram to be printed emulsion side down directly on top of the paper. This arrangement can be placed in a contact printing frame or it can be held in place by laying a piece of glass over it. Exposure from a strong light above must be timed according to the weight of the paper used for the original photogram and according to the intensity of the light. For example, with an enlarger set at f/4 as the light source, and using a photogram made on single-weight paper as the negative, exposure is about 1 minute for enlarging paper.

After exposure, process the print in the same way as you would any black-and-white print made in the darkroom. Photographic negatives and drawn negatives for clichés-verres can also be contact printed.

Clichés-verres

Camille Corot: "Le Petit Berger," about 1855. (The Metropolitan Museum of Art, Mortimer Schiff Fund, 1922.) The print was made from a drawing on glass.

Clichés-verres, translated from French, means glass prints and the term was originally used to describe photographic prints made by using drawings executed on glass as negatives. Artists of the Barbizon School, especially Camille Corot, experimented with clichés-verres. An etching needle was used to scratch lines from the painted surface of a glass plate, and a tapping instrument made dots among the scratches so the lines would be softened. The finished prints resembled etchings.

Today, plates for clichés-verres are drawn on any translucent or transparent surface — plexiglass or film, for instance. The plates can be built up, scratched into (or both), painted, sprayed, or dyed, and many materials (liquid or solid) can be applied to the clear surface. Varnish, oils, paint, gelatin, lacquer, and ink are just a few of these substances. Any material or method that will produce a creative image is valid. The plate is then placed in contact with photo-sensitive paper and exposed to light, or placed in the negative carrier of an enlarger and projected onto enlarging paper, and the print is processed normally in developers, stop bath, and fixer.

In the example shown by Figure 1, spray paint and varnish were sandwiched between two glass plates to create the negative. The plate was inserted into the negative carrier of an enlarger and a section of it was enlarged.

For Figure 2, a combination of ink and rubber cement was painted on glass. Sea ferns were placed on the glass before the glass negative was contact printed. As an additional experiment, the negative was printed without the sea ferns in place and, after the print was processed and dried, food coloring was applied with a paintbrush to parts of the black-and-white print (page 51).

The other prints in this section were made by students of Dr. Michael Andrews, of the Department of Synaesthetic Education, at Syracuse University; they demonstrate three different approaches to making clichés-verres plates.

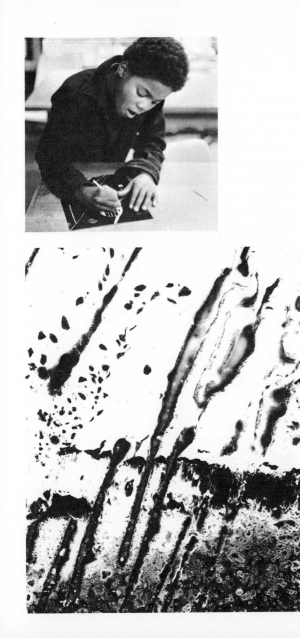

Top left: Student prepares a plate for clichés-verres. (Noel Hogans, fifth grade.)

Bottom left: Figure 1. Clichés-verres. Spray paint and varnish were smeared between two glass plates, which were put in the enlarger for exposure (f/11 at 45 seconds). *Bottom right:* Figure 2. Clichés-verres. Ink and rubber cement were painted on glass and a sea fern was superimposed over the glass for exposure to light.

61

"The Ship." The scene was painted on glass with opaque paint.

"The Ship" was painted on glass with black opaque paint. When the plate was printed, the black images became white and the clear background produced dark areas on the picture.

The opposite effect was created in "The Cat." Opaque paint was scratched away from a plexiglass surface with a sharp tool, leaving the figure of the cat.

The plate for the eagle print involved both the additive process of building up the subject on glass, producing the white lines in the lower half of the print, and the scratching away of portions of the surface, producing the black lines in the upper half of the print.

With such a variety of effects obtainable, clichés-verres offers one of the most intriguing challenges to be found in photography without a camera and the method is well worth exploring.

Opposite page: An eagle in clichés-verres. Black lines on the face were produced by removing paint from the glass plate. White lines in the body were produced by painting lines on the glass.

This page: "The Cat." The image of the cat was scratched away from the painted opaque surface of glass, resulting in black lines when printed.

7 Compositions on Film

In addition to drawing on plates, you can obtain your own negatives without a camera by making your compositions on film instead of on paper. These photograms can be contact printed and can also be projected in an enlarger to make an unlimited number of positive prints of the same subject.

Many techniques can be employed with these films and an enlarger. While projected, the film negative can be combined with objects placed directly on the photographic paper for unusual effects in the print. Instead of projecting the entire negative, sections of it can be chosen for enlargement in a print, and several films can be superimposed and printed together to create double or triple images.

Unique films on the market provide further possibilities for creating exciting images. A photogram on transparent film can be contact printed onto Kodalith Auto Screen Ortho film, which breaks the image up into small dots so that the picture resembles a photoengraving. When this new film image is projected in an enlarger and printed on paper or on another sheet of transparent film, the dots are greatly enlarged, adding another dimension to the photogram. The enlargement on paper will have the tones of the Ortho photogram reversed; but, if the enlargement is first made on transparent film and the results are then printed on paper, the final enlargement will have the same tones as the

Ortho photogram. The transparent film image can also be displayed as the final product.

Photograms on film do not have to be printed in order to be viewed. The transparency of the film's base makes these photograms suitable for projection in an overhead projector. Silhouettes or abstract images made on transparent film and projected onto a wall or a screen make excellent theatrical backdrops.

For display, the film can be backed with thin white or colored paper, sandwiched between clear glass or plastic sheets, and lit from behind. A light box with a bulb of 15 to 100 watts placed inside provides a perfect display case. If the glass sheet placed behind the film is frosted, or if the film is semi-opaque,

Equipment

TELESCOPIC LIGHT STANDS AND SOCKETS *(OR OTHER LIGHTING DEVICES DEPENDING ON THE TYPE OF FILM BEING USED)*
WHITE LIGHTS *(100 WATT BULB, 10 WATT BULB, OR 375 WATT PHOTOFLOOD)*
SAFELIGHTS *(25 WATT G.E. RUBY BULB)*
TRAYS, TONGS, SINK, AND TIMER

Supplies

DEVELOPER
STOP BATH
FIXER
FILMS: SEE PAGE 71 FOR FILM LIST AND EXPOSURE TIMES

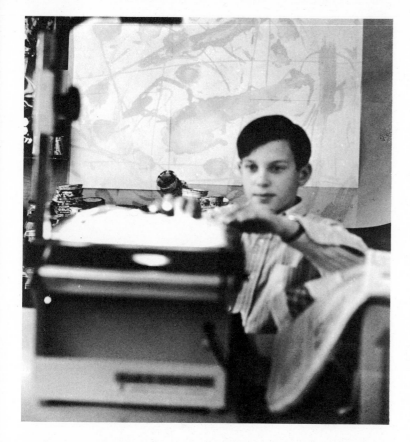

Above: An overhead projector is used to view a photogram made on film. (Jimmy Horowitz.)

Right: This photogram on Du Pont Cronar Ortho S Litho film was exposed for 3 seconds with a 10 watt bulb placed 4 feet above it.

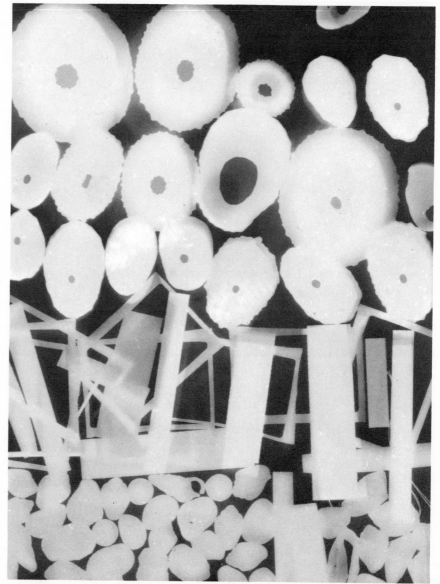

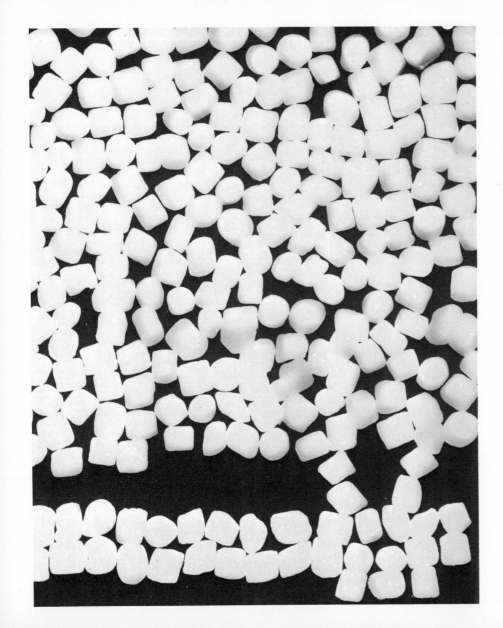

no paper backing is required to clarify the shapes or to diffuse the light. The wattage of the bulb depends on the size of the box and the density of the finished photogram. Lighting the box with a string of colored or clear blinker lights like those used on Christmas trees will create additional visual excitement. Using film as an art medium should prove to be very exciting and is certain to open up entirely new dimensions of creativity for the artist.

Photographic compositions are made on sheet films in exactly the same way as they are on paper and the processing involves the same steps for exposure, development and fixing. However, films do need a better safelight. A 25 watt G.E. ruby bulb or a standard darkroom safelight are both safe with all films listed.

For film, more varied exposure times and light sources must be devised. While some films have the same speed as either contact paper or enlarging paper, other films are extremely light-sensitive and must be exposed with a bulb of low wattage from a light source placed 7 feet away. These films can be exposed at 4 feet but a hot spot usually results. A white handkerchief placed over the bulb will help distribute the light more evenly. Several types of film can be handled in roomlight and will be described in Chapter 8. A list of films, exposure times, and types of light sources needed for making film photograms in the darkroom follows.

After processing, film is washed, but it is not blotted dry because the blotting paper would mar the emulsion. It is best to attach spring clips to the film and hang it up to dry.

Left: Small marshmallows were used to create these images on Agfa-Gevaert TP 7P clear film. Procedure is the same as for paper except that some films are more sensitive and require less exposure.

Opposite page: Tubes of paint were shifted twice during exposure of Supre-Lith Ortho film 303.

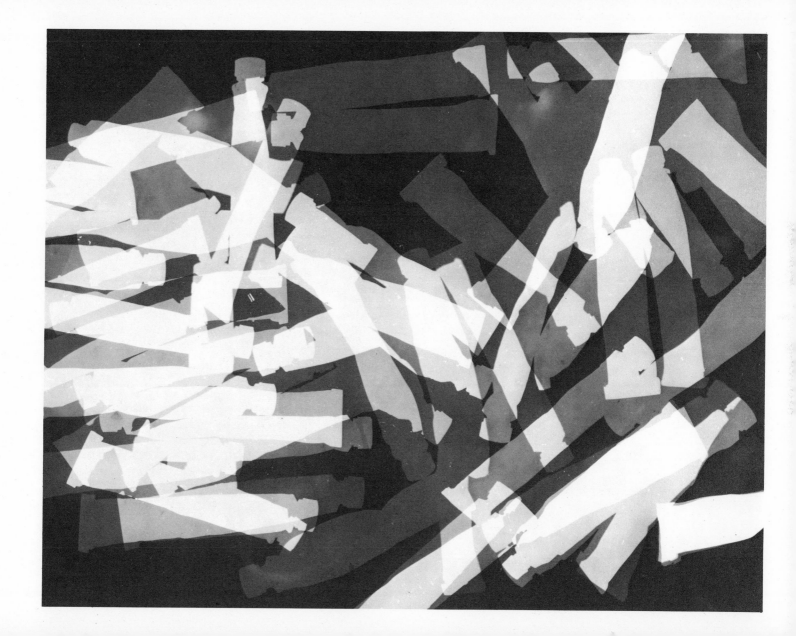

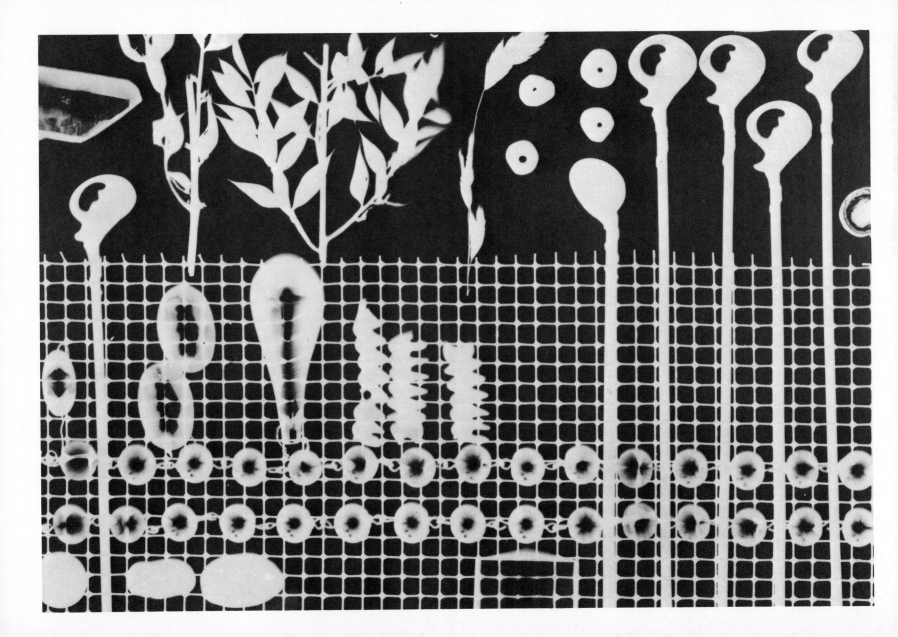

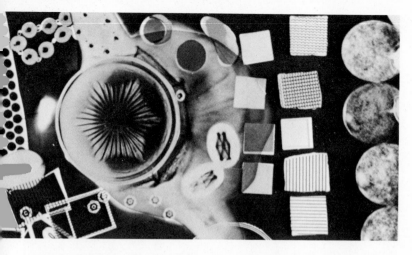

Above: Color was added to a black-and-white photogram made on Koda-lith Ortho Type 3 film by applying colored, adhesive-backed acetate sheets.

Right: Colored images on a black background were produced by using special enlarging paper (green Spiratone Psycho-Brome) which is de-veloped in standard black-and-white chemicals. Weeds were placed in contact with the paper and exposure was made with a bare bulb for ½ second.

Opposite page: A wire screen was placed on Kodalith Translucent Mater-ial and other objects were arranged over the wire. The film was exposed from a height of 10 feet for 4 seconds with a 10 watt bulb.

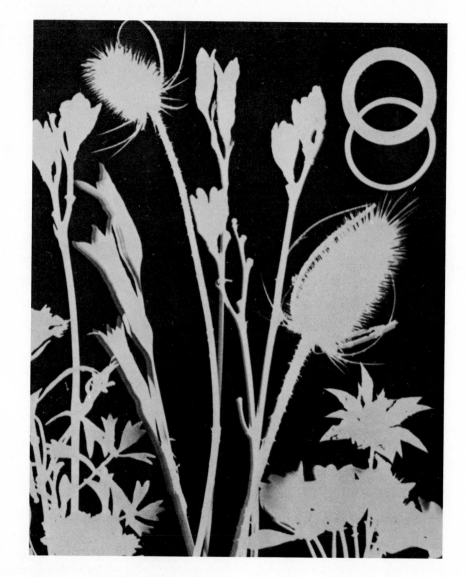

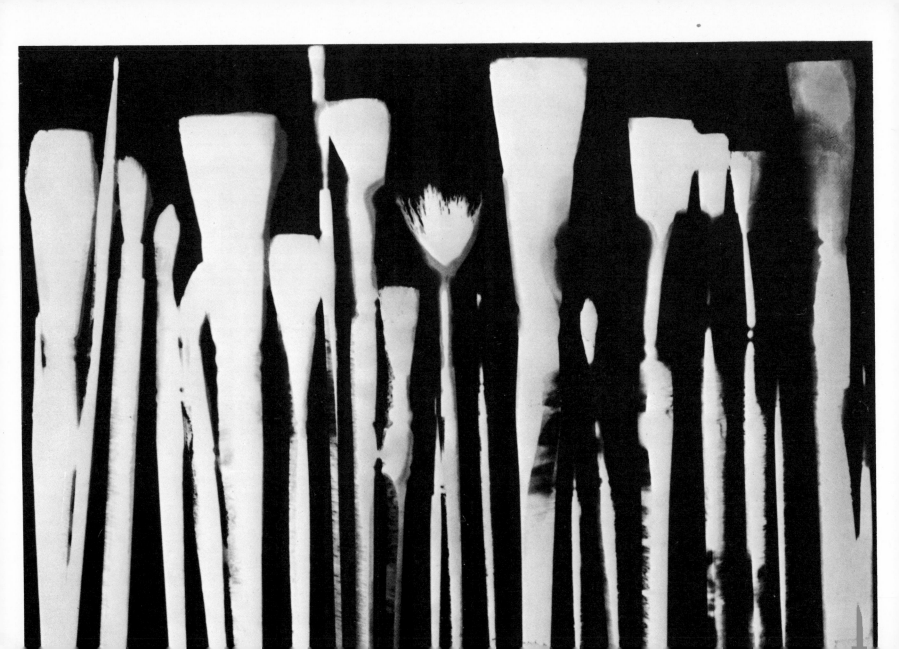

Films and Exposure Times

Agfa-Gevaert TP7P (Transparent)
 25 watt bulb at 4 feet. Expose for less than 1 second.
Du Pont Adlux (Translucent)
 25 watt bulb at 4 feet. Expose 10 seconds.
Du Pont Cronapaque (Semi-opaque, white)
 100 watt bulb at 4 feet. Expose for less than 1 second.
Du Pont Cronar Ortho S (Transparent)
 10 watt bulb at 4 feet. Expose 3 seconds.
GAF Litho Film A-557 (Transparent)
 10 watt bulb at 4 feet. Expose for less than 1 second.
GAF Graphic P-407 Litho Film (Transparent)
 10 watt bulb at 4 feet. Expose 3 seconds.
Kodagraph Contact Film 2580 (Translucent)
 100 watt bulb at 4 feet. Expose 10 seconds.
Kodalith Ortho Type 3, 6556 (Transparent)
 10 watt bulb at 6 feet. Expose 3 or 4 minutes.
Kodalith Translucent Material (Translucent)
 10 watt bulb at 7 feet. Expose 3 or 4 seconds.
Supre-Lith Ortho Film 303 (Transparent)
 25 watt bulb at 4 feet. Expose for less than 1 second.

Opposite page: Standard color toners have been painted on sections of a black-and-white print with a brush to form a multi-colored composition.

Right: Both opaque and translucent items were used for this composition on Kodalith Ortho Type 3 film.

Coloring Films

Color toning the films is effective, and is handled in a manner similar to the process for toning paper. Du Pont Adlux translucent film and Du Pont Cronapaque semi-opaque white film can be immersed in FR Develochrome for development and the background will become the color of the toner (page 52). Kodagraph Contact Film 2580 (like the roomlight handling film Kodagraph Autopositive Clear Film 2920) can be developed in Develochrome, and the background and the images both take on different shades of the toner when processed for an ample period of time.

All other films mentioned here (except GAF Litho Film A-557 and GAF Graphic Litho Film P-407, which do not accept any color toners) work best when they are processed normally and are then placed in a standard color toner. The colors blue, red, and yellow are best on the transparent films. All the colors work well on the translucent films (such as Du Pont Adlux, Kodagraph Contact Film 2580, and Kodalith Translucent Material) and on the semi-opaque Cronapaque film. The images become the color of the toner and the background remains black. Like the paper, if the film is left in the toner too long, the blacks disappear.

Most films can also be drawn on with magic marker or with retouch dyes; and pencil and ink can be added to the surface of others.

Left: This photogram on Du Pont Adlux film was processed in standard black-and-white developer. Compare this with photogram on page 52.

Opposite page: One-half of the film was covered by an opaque metal grater, while the other half was given a circular design, resulting in strong positive and negative shapes (GAF Lithofilm A557).

Printing in Roomlight

On Paper and Film

Roomlight printing offers good experience in photography. Processing these prints requires the same supplies and equipment used in the darkroom, minus an enlarger and safelights. The papers and films used are less light-sensitive than those used in the darkroom, and they are normally employed by engineers and architects for drawing reproductions. Used with photogram techniques they offer ample opportunity for creative expression.

Despite their slow speed, the papers and films should be handled with some care. A regular classroom or room with the lights turned off would suffice for working with roomlight handling materials. In addition, if the window shades were pulled down, the light in the room would be even more subdued and would allow a longer time to arrange the composition. Each sheet of paper or film should be removed from its package only as it is needed because prolonged exposure to light will eventually produce fogging. For this reason, arrange the design away from the window and don't take more than 3 to 5 minutes to compose the design.

It is sometimes difficult to determine the correct amount of exposure the prints will need. Exposure time depends on how close the light source is to the paper or film, the speed of the paper or film being used, and the wattage of the light bulb. A 100 watt house light is fine for use with most roomlight materials

and exposure can be easily controlled. If less than 100 watts are used, exposure time will have to be increased. The light from a 375 watt photoflood lamp is too intense for some roomlight

Opposite page: Kodagraph Repro-Negative R1 paper results in a negative print (light images on dark background). Print was made by a third-grade student at The Workshop for Learning Things in Newton, Massachusetts.

Right: Kodagraph Autopositive Clear Film 2920, like the Autopositive papers, produces a positive print (dark images on a light background) instead of a negative one.

Equipment

TIMER OR CLOCK WITH A SECOND
 HAND
3 LARGE TRAYS
2 PAIRS OF TONGS
MEASURING SPOONS
GRADUATED MEASURING VAT
STORAGE BOTTLES FOR
 SOLUTIONS
SINK
BLOTTERS
WHITE LIGHT *(100 WATT LIGHT,*
375 WATT PHOTOFLOOD,
FLUORESCENT LIGHT, OR SUN-
LIGHT, DEPENDING ON THE
TYPE OF ROOMLIGHT PAPER
BEING USED)
ASSORTMENT OF OBJECTS TO
 USE IN MAKING THE DESIGNS

Supplies

DEVELOPER
STOP BATH
FIXER
VEGETABLE DYES
EDWAL COLOR TONERS
 (IF DESIRED)
KODAK SEPIA TONER
 (IF DESIRED)
FR DEVELOCHROME *(IF DESIRED)*
ROOMLIGHT HANDLING PAPERS
 AND FILMS: SEE THE END OF
 THE CHAPTER FOR TYPES AND
 EXPOSURE TIMES

Top: Kodagraph Autopositive A1 paper automatically produces a positive print when exposed and processed normally. In the picture below, the same paper was exposed with a 375 photoflood instead of a 100 watt bulb and the images were reversed from positive to negative due to solarization. *Right:* Upon brief exposure with a 375 watt photoflood, the paper produced a partially solarized print.

papers and films but it can be used effectively on some papers with less exposure time than is required for a 100 watt bulb. Sometimes interesting solarized effects take place as a result of the intensity of the lamp.

The developer, stop bath, and fixer should be mixed according to the directions on their containers. (These are the same chemicals that are used for processing photographic paper and film in the darkroom.) Each should then be poured into its own tray, with the trays in the order they will be used. The sink should be cleared for rinsing prints.

After arranging the design items on the paper or film, expose the print for the required amount of time. Then remove the objects and set the print into the developer, sensitive side up so the latent image can be seen as it begins to emerge. Agitate the print gently, holding one corner of the paper or film with tongs. There is no specific amount of time the print should stay in the developer. If only opaque objects are used for the design, development will be simple because the images will remain white and the background will turn black, brown, or will be clear, depending on the type of paper or film chosen. If translucent objects are used, the print must be carefully watched and removed from the developer exactly at the point when the desired shades appear.

At the right moment, lift the print out of the developer, gently shaking off excess developer over the tray, and place it into the stop bath for a few seconds. Remove the print, shaking off excess stop bath, and place the print into the fixer for about 5 minutes. Agitate the prints occasionally so they will not stick together. The prints should then be set into the sink, or into a tray, and washed with cool, running water for about 30 minutes. The final step is to hang the prints up and let them dry.

Positive print made on Kodagraph Autopositive AQ1 paper was exposed with an overhead fluorescent light at 6 feet for 10 minutes.

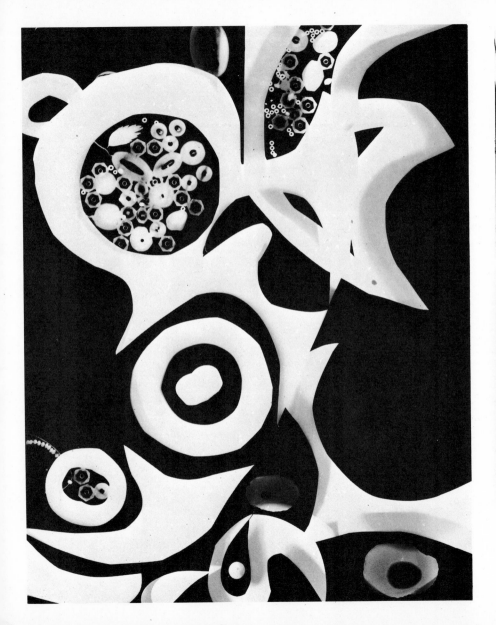

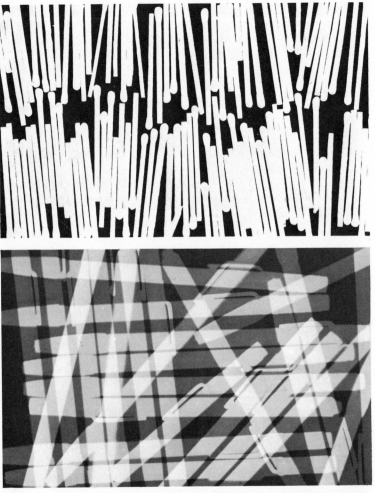

Above: Matchsticks form a repeat design on the print (Agfa-Gevaert Rapido Print TC4 paper, exposed with a 375 watt photoflood). In the picture beneath, a series of pens was shifted twice during exposure to cast double images (Supre-Print Type A paper).

Left: Agfa-Gevaert FC1 (Grade 4) paper produces high contrast. Exposure was made with a 100 watt bulb.

Roomlight Handling Papers — Exposure Times

Agfa-Gevaert Rapido Print TC4
 100 watt lamp at 2 feet. Expose 10 seconds for negative image.
 375 watt photoflood at 3 feet. Expose 2 seconds for negative image.

Agfa-Gevaert FC1 (Grade 2)
 100 watt lamp at 2 feet. Expose 3 seconds for negative image.
 375 watt photoflood at 4 feet. Expose for less than 1 second for negative image.

Agfa-Gevaert FC1 (Grade 3)
 100 watt lamp at 2 feet. Expose 5 seconds for negative image.
 375 watt photoflood at 4 feet. Expose 1 second for negative image.

Agfa-Gevaert FC1 (Grade 4)
 100 watt lamp at 2 feet. Expose 10 seconds for negative image.
 375 watt photoflood at 4 feet. Expose 1 second for negative image.

Kodagraph Autopositive, ultra thin, A1
 100 watt lamp at 2 feet. Expose 5 minutes for positive image.
 375 watt photoflood at 3 feet. Expose 3 minutes for solarized negative image or partially reversed negative image.

Kodagraph Autopositive, ultra thin, AQ1
 100 watt lamp at 2 feet. Expose 3 to 5 minutes for positive image.
 375 watt photoflood at 3 feet. Expose 3 minutes for solarized negative image.
 Fluorescent light at 6 feet. Expose 10 minutes for positive image.
 Sunlight. Expose 10 minutes for solarized image.

Kodagraph Repro-Negative, ultra thin, R1
 100 watt lamp at 2 feet. Expose 5 minutes for negative image.
 375 watt photoflood at 3 feet. Expose 1 minute for negative image.
 Sunlight. Expose 30 seconds or less for negative image.

Supre-Print, Type G, extra hard
 100 watt lamp at 2 feet. Expose 20 seconds for negative image.
 375 watt photoflood at 3 feet. Expose 1 second for negative image.

Supre-Print, Type D-S, extra hard
 100 watt lamp at 2 feet. Expose 45 seconds for negative image.
 375 watt photoflood at 3 feet. Expose 2 seconds for negative image.

Supre-Print, Type A, extra hard
 100 watt lamp at 2 feet. Expose 45 seconds for negative image.
 375 watt photoflood at 3 feet. Expose 2 seconds for negative image.

Roomlight Handling Printing Out Papers — Exposure Times

Agfa-Gevaert P.O.P.
 375 watt photoflood at 1 foot. Expose 5 minutes.

GAF Proof Glossy
 375 watt photoflood at 1 foot. Expose 5 minutes.

Kodak Studio Proof F
 375 watt photoflood at 1 foot. Expose 10 minutes.

Roomlight Handling Films — Exposure Times

Kodagraph Autopositive Film, 2576
 100 watt lamp at 2 feet. Expose 13 minutes.
 375 watt photoflood at 4 feet. Expose 5 minutes.

Kodagraph Autopositive Clear Film, 2920
 100 watt lamp at 2 feet. Expose 10 minutes.
 375 watt photoflood at 4 feet. Expose 2 minutes.

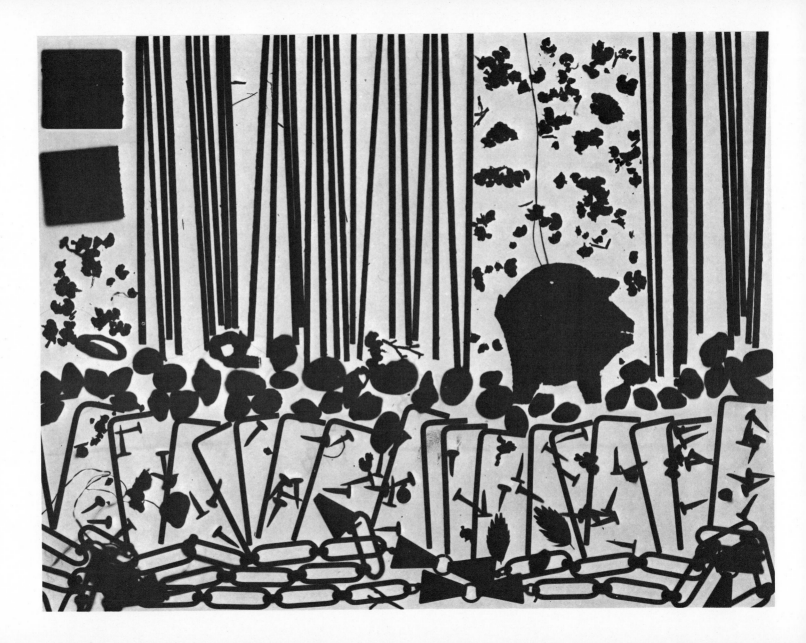

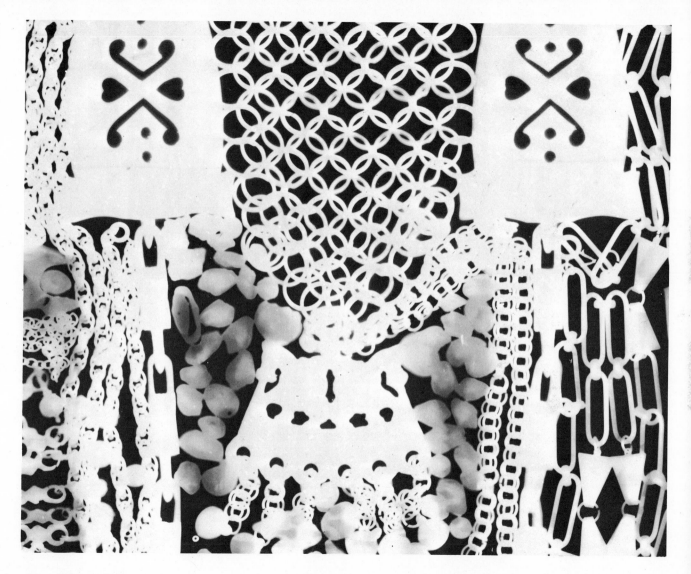

Opposite page: Exposure was made with a 100 watt bulb on AQ1 paper, producing a positive print.

Above: Exposure was made on Supre-Print Type G paper with a 100 watt bulb.

Coloring Roomlight Prints

After the prints made on roomlight handling papers have been developed and fixed, they can be color toned in various ways. A tablespoon of vegetable coloring mixed with 16 ounces of water makes the best colorant for all roomlight papers. A wash of 30 minutes is best after toning with vegetable colors. Edwal's standard toners and Kodak's sepia toner will also produce satisfactory colors, though not as bright as the vegetable coloring solutions. Be careful not to immerse the papers in the standard toner too long or the blacks will disappear. A wash of 10 minutes is required after toning prints with standard toner.

When toned, Kodak's Autopositive papers, which automatically produce positive images (black on white), will produce a black image on a colored background. The other roomlight papers in the list that follows produce a negative image, so the shapes will be in color and the background will remain black. The heavier weight papers are more readily color toned than the lightweight ones when standard toners are used. Vegetable coloring works well on all weights of paper.

Kodagraph Autopositive Clear Film 2920 can be colored by placing it in FR Develochrome color toner immediately after exposure. The image and the background will be dark and light shades of the color (page 87). After toning, use color fixer, then wash and dry as usual. Standard toner does not work well on this film, and neither standard nor direct toners work well on Kodagraph's Autopositive Clear Film 2576.

Most roomlight handling papers and films will accept the addition of color by hand application, either with magic marker, retouch dyes, or vegetable coloring. Pencil and ink can also be applied to some papers.

Colored Photo-Sensitive Film

The 3M Rainbow Color Key Pack consists of 25 sheets of light-sensitive films in assorted colors. They can be handled in roomlight and will allow the artist to make many inventive pictures with color. The film comes transparent or opaque, is negative or positive acting, and can also be had in single colors in various quantities.

One way to use this versatile material is to place any of the following on transparent negative-acting film: a transparentized photogram on single-weight paper, a drawing on vellum or other thin paper, a negative, or various three-dimensional objects. Exposure can be made by sunlight, or with two 250 watt bulbs (for $3\frac{1}{2}$ minutes), or with a 1000 watt bulb (for 1 minute).

3M Developer Fluid is then rubbed over the surface of the film. This removes the colored emulsion and reveals clear film in those areas where light was prevented from passing through. Color is left on the remaining portions of the film.

This process can be repeated using several colors of film and various negatives. The completed photograms can be sandwiched together to form a new design. Any number of ideas can evolve as a result of experimenting with this unique material.

 Examples

The photographs in this chapter represent a variety of ways photograms can be made using an enlarger or a bare bulb as the light source. A contact printer could also be employed where two-dimensional items have been used in making the arrangement. When an enlarger has been the light source, the apertures and exposure times, as well as the paper types, are mentioned in the captions. But many other papers and different aperture settings and exposure times can certainly be used by the artist. The proper exposure depends primarily on the type of paper being used, the intensity of the light being used, and how close the light source is to the paper.

It is possible to achieve many variations of these examples; experimentation and experience will introduce many additional techniques. The possibilities are as great as the artist's imagination.

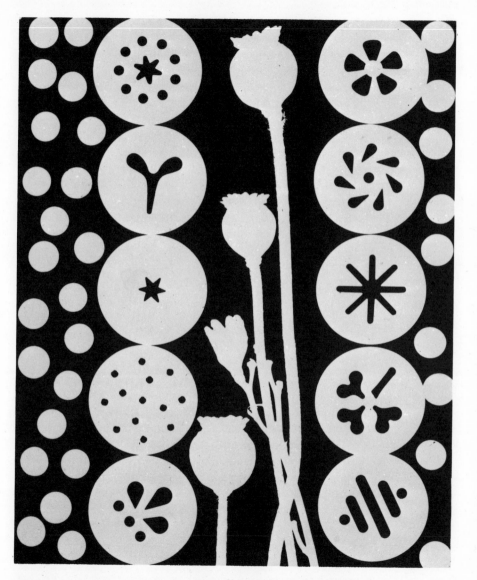

Objects were placed in contact with yellow Spiratone Psycho-Brome. Light source was an enlarger (f/11 at 45 seconds).

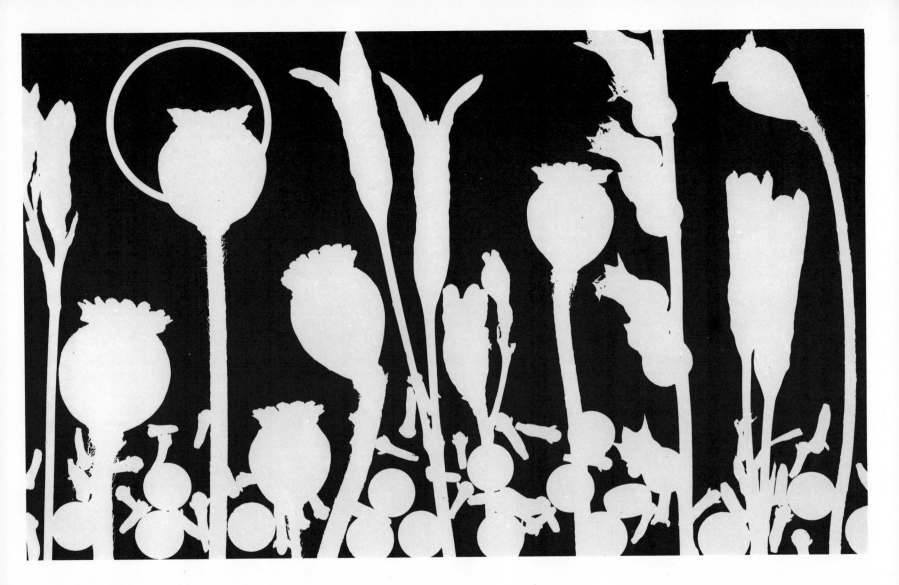

Weeds were placed on Photo-Aluminum. Light source for exposure was
an enlarger (f/11 at 20 seconds).

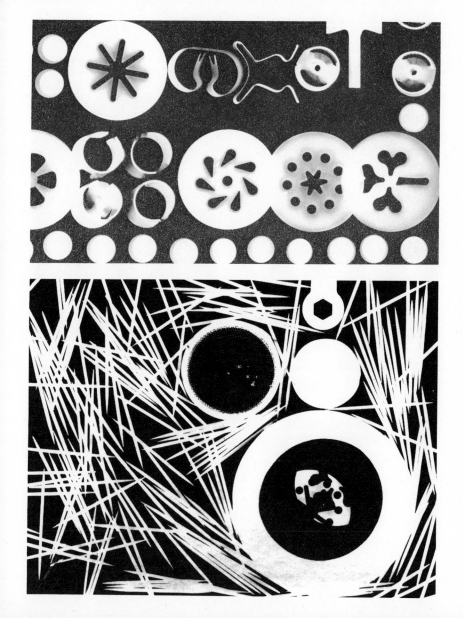

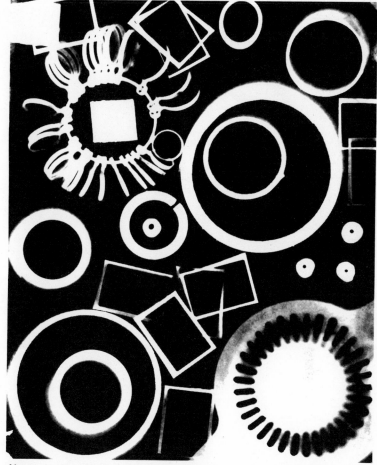

Above: Luminos pastel enlarging paper also gives colored images on a black background. Objects were placed on the paper; exposure was with a bare bulb for ½ second.

Left above: Objects were placed on Spiratone Crystal enlarging paper. Light source was an enlarger (f/11 at 45 seconds). *Left:* Special surface enlarging papers produce colored images with standard black-and-white processing. This print was made on red Spiratone Psycho-Brome. Objects were placed in contact with the paper; light source was an enlarger (f/11 at 45 seconds).

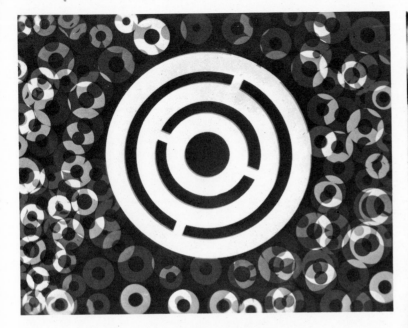

Above: Luminos pastel enlarging paper (red). Coins surrounding the center stationary circle were shuffled five times during a 20-second exposure. Light source was an enlarger at f/11.

Right: Spiratone Silver-Brome. Glass coated with spray varnish and paint was placed in the negative carrier space and enlarged (f/8 at 20 seconds).

Above: Kodagraph Autopositive Clear Film 2920 is handled in roomlight and can be successfully processed in Develochrome. Background of the film will be lightly colored, while images will be dark in color because this film produces a positive image instead of a negative one.

Right: The exposed print (on paper) was developed to finality in black-and-white developer and fixed in the darkroom before it was color toned in standard green toner.

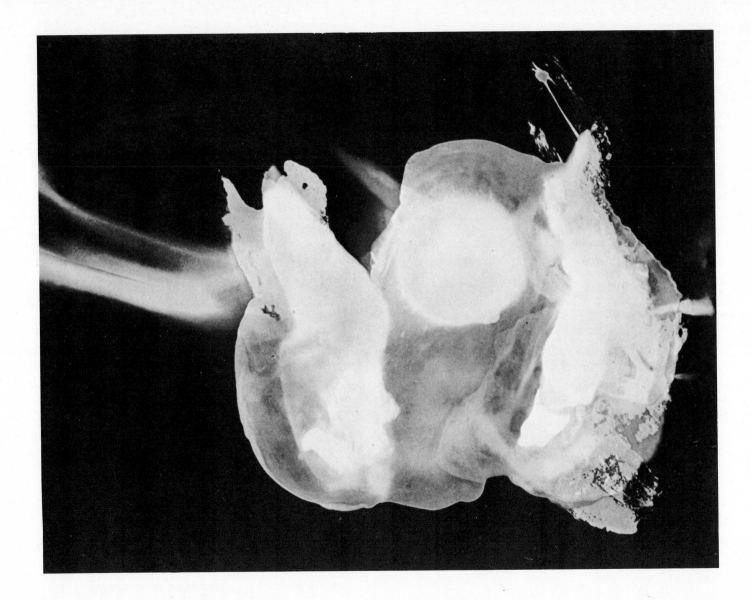

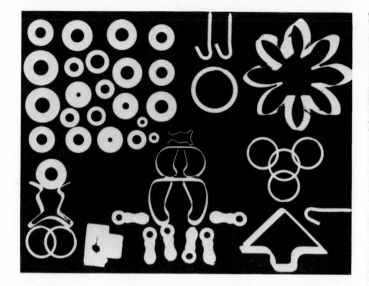

Supre-Print PM Gold. Objects placed in contact with the paper result in gold-colored images. Light source was an enlarger (f/11 at 45 seconds).

Opposite page: Robert Heinecken: "Documentary Photogram/ Breakfast," 1971. (Permission of the artist.) Photogram of an egg with the addition of color.

Xerox print. Two-dimensional objects were placed in a copying machine and exposed.

Left: Agfa-Gevaert Brovira enlarging paper (#6). Scraps of exposed film were placed in the negative carrier and enlarged (f/11 at 40 seconds).

Opposite page: Kodak Koda-bromide enlarging paper. An orange slice was placed between two pieces of glass and put in the negative carrier space for enlargement (f/11 at 45 seconds).

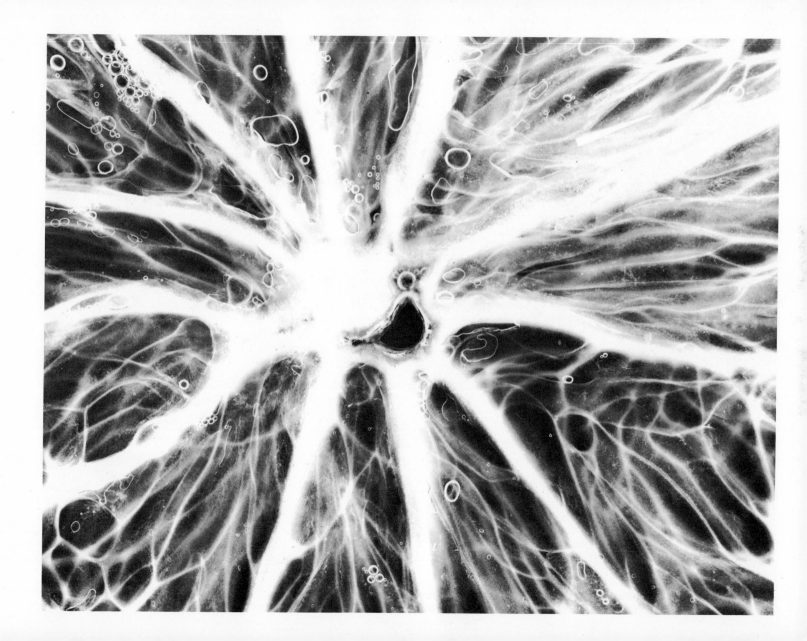

Two transparent glass objects placed on contact paper produced large circular designs, while opaque stirrers produced solid white images.

Cloudy white area is the shadow projected by glass sugar bowl which was 6 inches high. (Exposed with a 75 watt bulb for ½ second.)

Top right: A negative of parallel stripes was made on Kodalith Ortho Type 3 film. The negative was projected onto enlarging paper. One edge of the paper (Agfa-Gevaert Brovira) was bent up during exposure (f/8 at 25 seconds). The paper nearest to the enlarger light was masked with both hands to avoid overexposure in that area. *Bottom right:* GAF Jet enlarging paper. Cut paper shapes placed on the paper form the images. Center shadow was produced by dodging the area during exposure. Enlarger at f/11 for 35 seconds.

Above: Silhouettes of skyscrapers were made first on Kodalith Ortho Type 3 film. The processed film was then placed in the negative carrier and projected onto an arrangement of hinges, gauze, and cylinders placed on the enlarging paper (Kodabromide). Exposure for negative and objects printed together was f/11 at 45 seconds.

Du Pont Velour Black RW4 enlarging paper. In the darkroom, developer was painted on some sections of the paper. Objects were then arranged on the paper and the design was exposed with light from an enlarger for 20 seconds at f/11. Then the objects were moved slightly and the new design was exposed for another 15 seconds. Paper was then developed briefly.

Agfa-Gevaert Brovira enlarging paper. Glass beads were placed in the negative carrier space and enlarged (f/11 at 30 seconds).

Opposite page: GAF Jet enlarging paper. One-half of the print was contact printed from a negative photogram. The other half of the print, which was covered to prevent exposure during the contact printing of the first half, was made with objects placed directly on the paper. Objects were chosen to repeat the previous motif, and the contact-printed half was covered while the new exposure was made.

Left: Agfa-Gevaert Brovira enlarging paper (#6). A tomato slice was placed between sheets of glass in the negative carrier space and enlarged (f/11 at 30 seconds).

Above: Du Pont Velour Black RW2. Glass beads were placed in the negative carrier and enlarged (f/11 at 20 seconds).

Opposite page: A shallow glass tray containing soap bubbles was placed in the negative carrier space for enlargement (f/11 at 20 seconds) on Brovira #6 paper.

Above: A shallow dish containing oil and vinegar was placed in the negative carrier space and projected onto Adlux film. The film was processed and a section of the resulting negative was enlarged on Brovira #6 paper.

Plastic objects were placed on contact paper and illuminated from the sides with lighted matches.

Objects placed on the paper were illuminated from two sides by flashlights. A wire screen was held in front of one light.

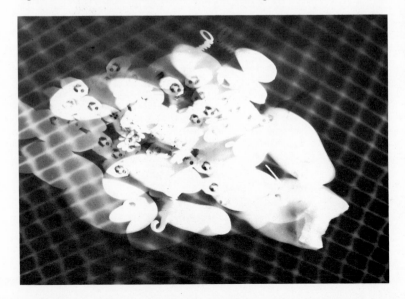

Above: Kodabromide enlarging paper. Copper wire kitchen scrubber was stretched and placed in the negative carrier space for enlargement (f/8 at 20 seconds).

Opposite page: Kodabromide enlarging paper. Both corrugated plastic and punched shapes were placed on paper for exposure. (Photogram by Kirk Prouty, photographer.)

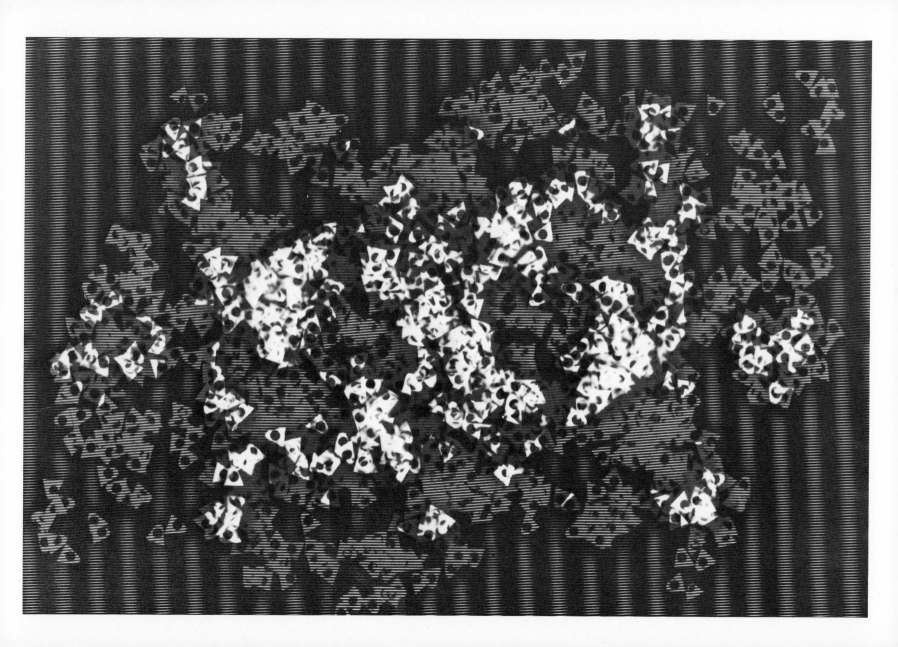

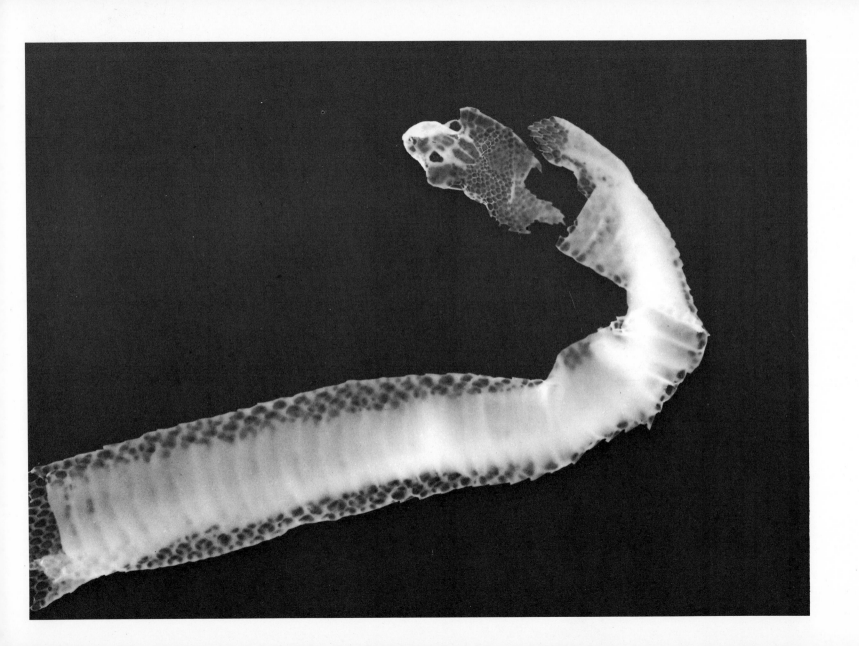

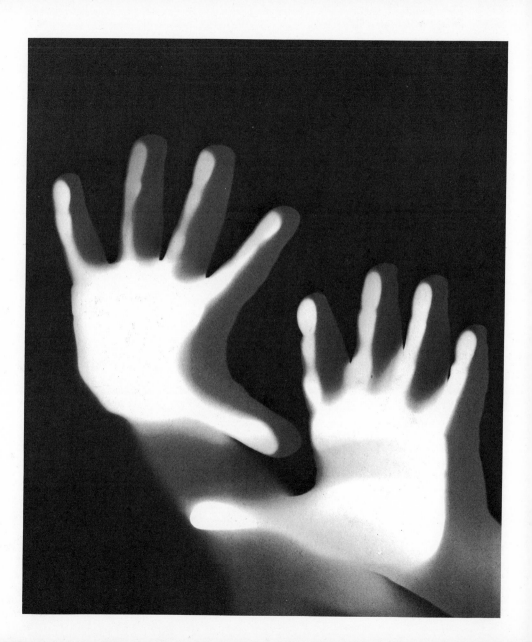

Opposite page: A snake skin was placed on contact paper for exposure (75 watt bulb at 2 feet for ½ second).

Right: Exposure was made of a child's hands placed directly on photo paper. (Print by a student in the Department of Synaesthetic Education, Syracuse University.)

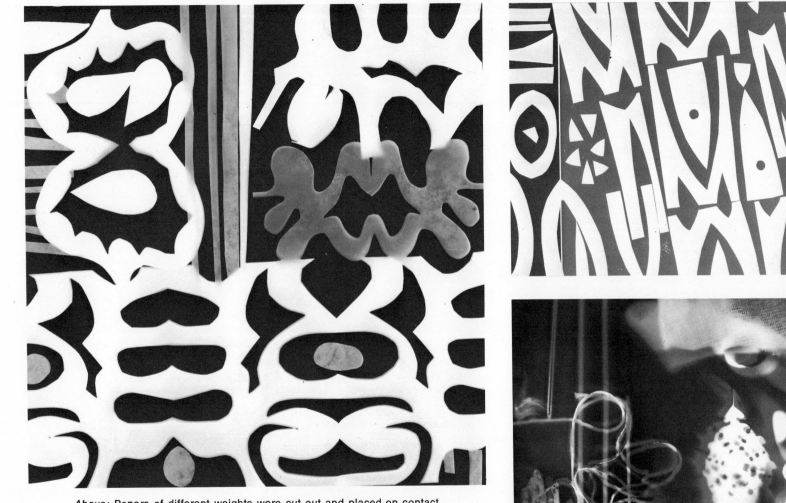

Above: Papers of different weights were cut out and placed on contact paper for exposure (75 watt bulb at 2 feet for ½ second). *Top right:* A glass sheet was placed over paper shapes on contact paper. The print is darker where the glass sheet ended because exposure was not diffused. (75 watt bulb at 2 feet for 1 second.) *Bottom right:* Contact paper was moved slightly beneath objects during exposure, to blur images (75 watt bulb for 1 second).

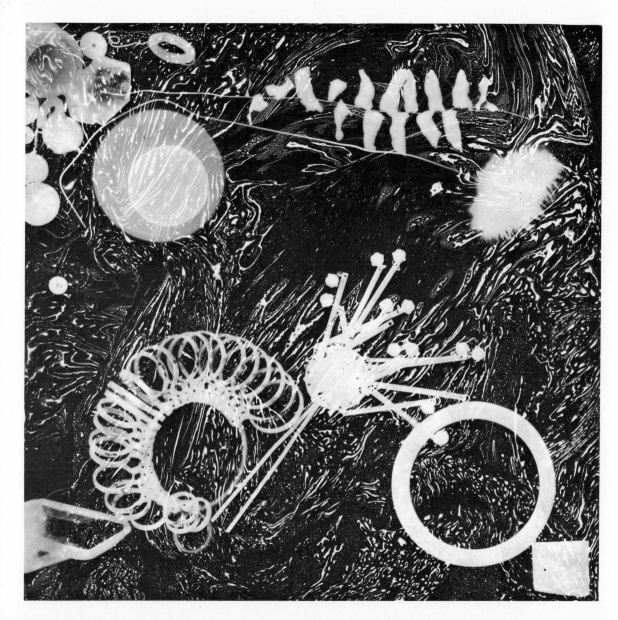

Objects were placed on contact paper and exposed. Turpentine and cold cream were floated on the developer and the print was then dragged through the solution, resulting in marbleized images.

103

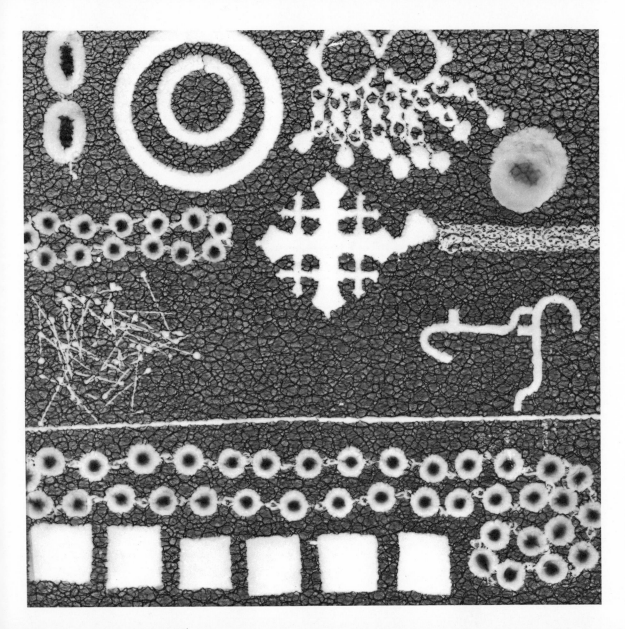

Left: Objects were placed on top of textured glass laid against contact paper for exposure (75 watt bulb at 2 feet for ½ second).

Opposite page: In the picture at top left, lines were drawn directly on contact paper with a pocket flashlight. The same technique was used to make the sketch of the lady's head, at the right. In the picture at the bottom left, the flashlight lines were drawn around objects placed on contact paper and the arrangement was also given a brief overall exposure.

Above: Kodak Medalist enlarging paper. A cookie cutter was placed in the negative carrier space and moved three times during a 45-second exposure at f/8.

Right: A three-dimensional glass and Seran-Wrap were placed on contact paper for exposure (75 watt bulb at 2 feet for ½ second).

106

Above: Luminos pastel enlarging paper (yellow). Objects placed on the paper were illuminated with an enlarger (f/11 at 45 seconds).

Left: Newspaper items were dampened and contact printed (60 watt bulb at 2 feet for 1 second).

Left: Coins, washers and cookie cutters were moved on the paper (Brovira #6) five times during a 20-second exposure. Light source was an enlarger at f/11.

Opposite page: Plastic boxes were placed on contact paper and exposed (45-watt bulb at 2 feet for 1 second).

Left: GAF Jet enlarging paper. A feather was placed in the negative carrier and enlarged (f/11 at 20 seconds). A contact print was then made from the original enlargement.

Above: Supre-Print projection paper. No design objects were used. The paper was placed in a tray of water and agitated during exposure. Light source was an enlarger (f/4 at 5 seconds).

Opposite page: The picture at the top left is a contact print from a solarized photogram. Weeds were placed on Brovira paper and the print was exposed for 10 seconds with an enlarger light at f/11. Three-quarters of the way through development, the paper was exposed again at f/11 for another 5 seconds, before it was developed to finality. After fixing, thin white lines appeared around the images. When the solarized photogram was contact printed the lines were reversed to black.

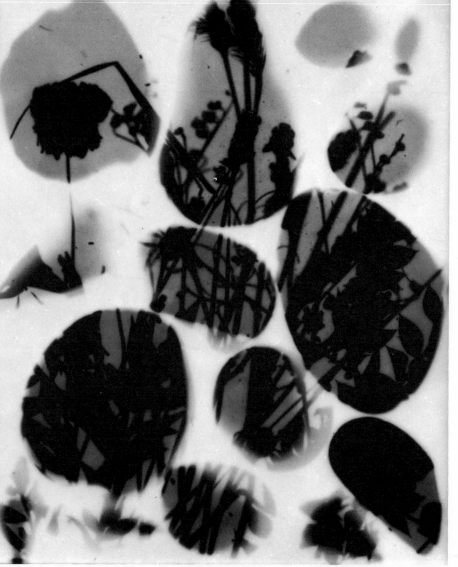

Right: Negative on Du Pont Adlux film and one on Kodagraph Autopositive 2920 film were sandwiched together between glass sheets and contact printed.

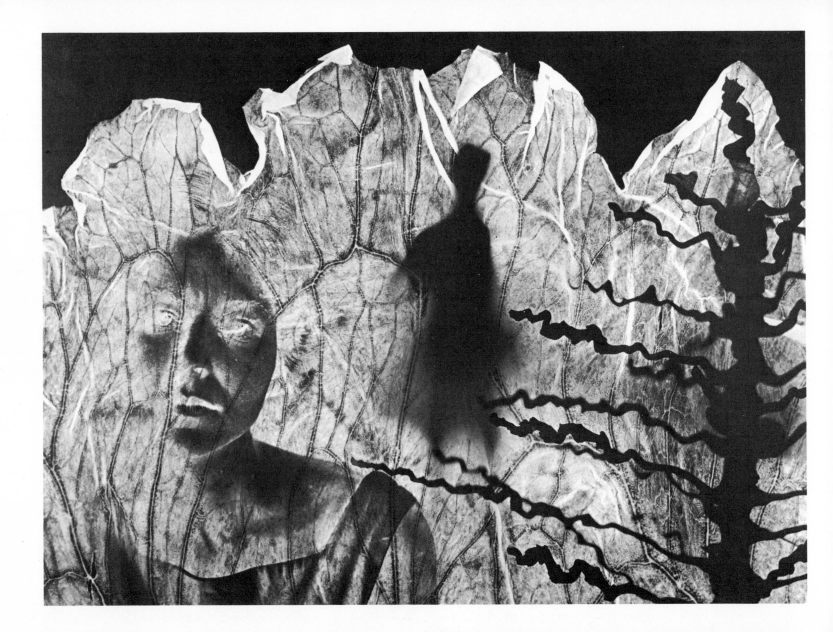

 Illustrations

The illustrations in this chapter were made by contemporary photographers and other artists who have created very special pictures in the darkroom. Utilizing the darkroom as a laboratory for visual exploration rather than just as a place in which to process prints, these artists accept the challenge of creating totally new or transformed images. They are not concerned solely with picture images produced by the camera. Consequently, their work is highly original and each print is unique.

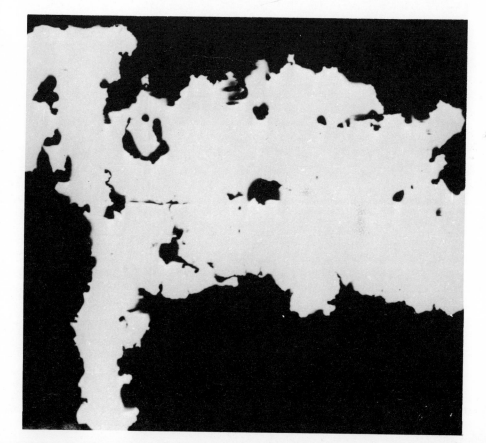

Opposite page:
Jerry Uelsmann: "Conjecture of a Time," 1964. (Permission of the artist.) Found objects, in this case a lettuce leaf, are combined with camera negatives.

Right:
Kirk Prouty: "Rusted Metal," 1966. (Permission of the artist.) A rusted metal form has been used to create strong positive and negative shapes.

Left: Lotte Jacobi: Untitled work from series "Photogenics," 1949-1959. (Collection, The Museum of Modern Art, New York. Gift of Edward Steichen.) Ribbons of movement are produced by the creative use of light.

Alan Sonfist's sculpture "Crystal Enclosure," 1969, employs light-sensitive materials, which are trapped within a structure and react continually to heat, cold, light, and time. (Photograph below courtesy of the artist.)

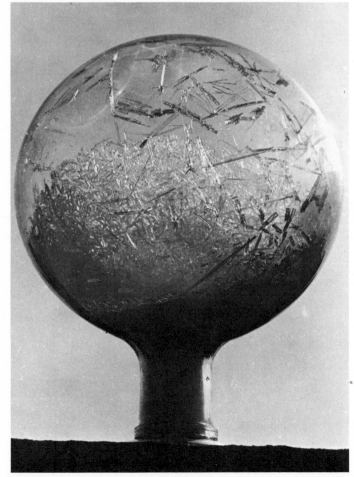

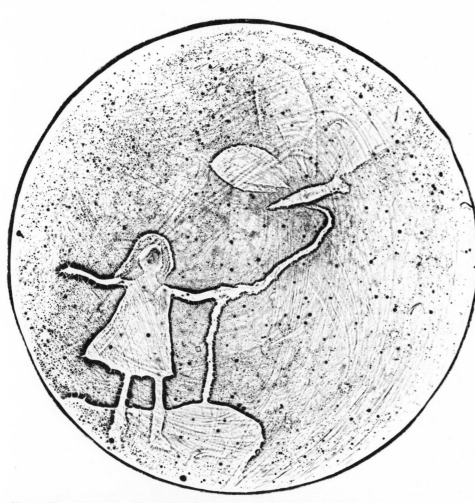

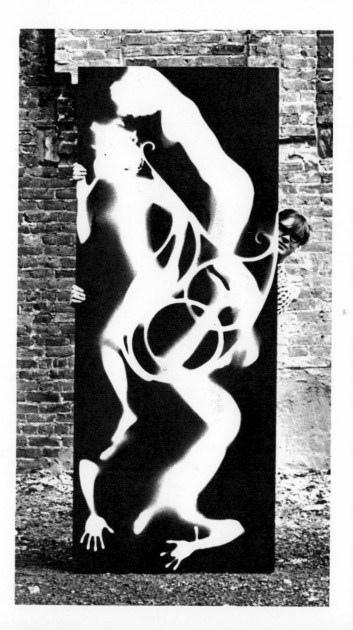

Above: Naomi Savage: "The Kite." (Permission of the artist.) A niece of American art innovator Man Ray, Naomi Savage created a photogram negative on high contrast graphic film (Ortho) and made the enlarged print on Kodak Ektalure X (tapestry textured paper).

Right: Dennis Martin: "Photogram," 1965. (Permission of the artist.) Life-size silhouettes of people and of a rocking chair are combined in one picture. Special trays were made to process the huge prints.

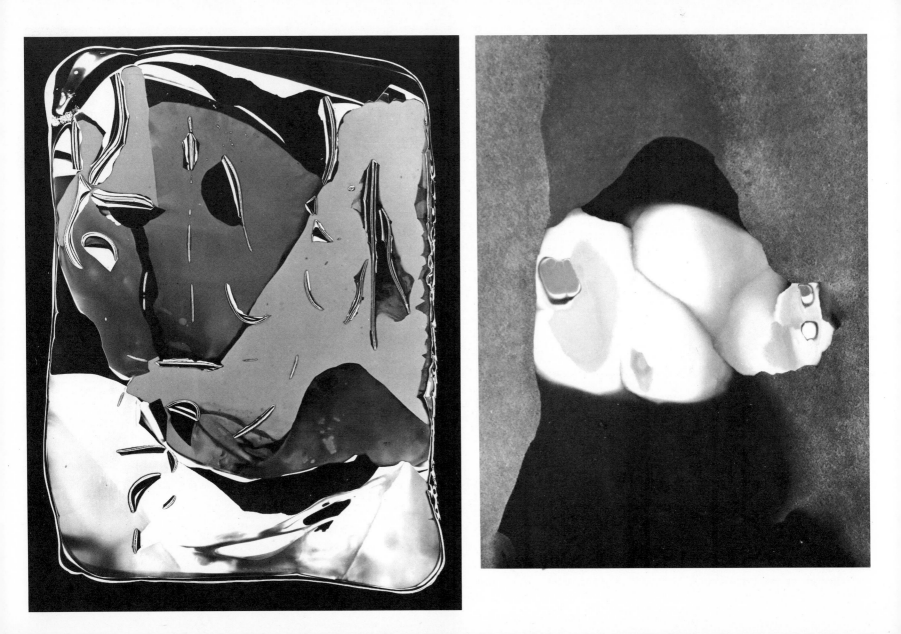

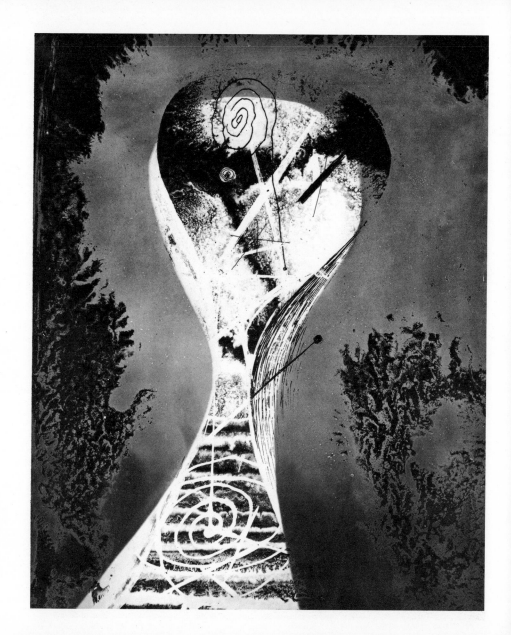

Opposite page: Pierre Cordier: "Chimigramme," 1957, and "Chimigramme" (detail). (Permission of the artist.) Chemical actions on a light-sensitive surface are carefully controlled to obtain images.

This page: Gyorgy Kepes: "Abstraction #4," 1942. (Collection, The Museum of Modern Art, New York. Gift of the artist.) Clichés-verres technique.

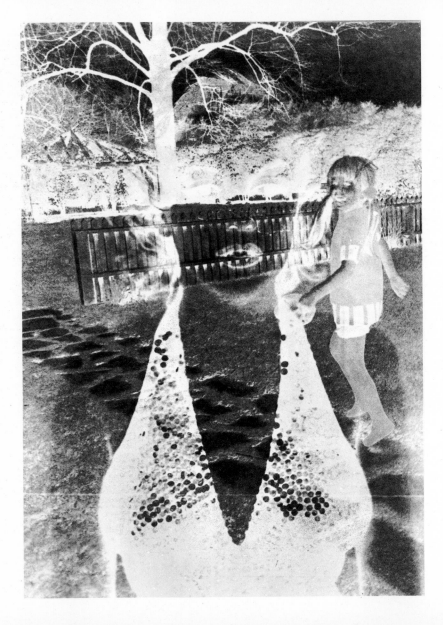

Robert Heinecken: "Marilyn Monroe and Child," 1968. (Permission of the artist.) Two photographs were contact printed onto light-sensitive paper.

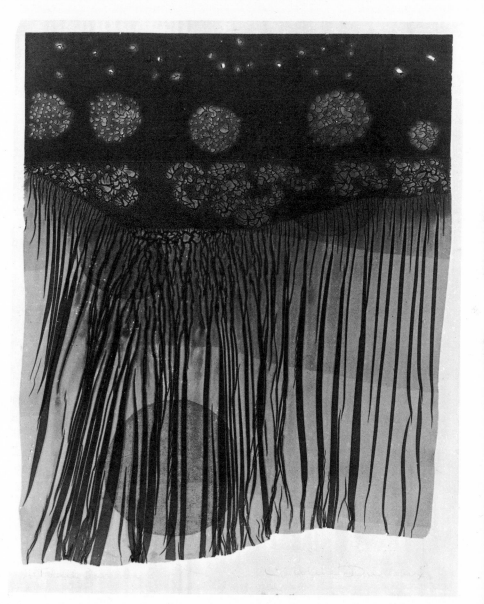

Caroline Durieux: "Frail Banner," 1961. Clichés-verres dye print, 15 x 11⅞". (Collection, The Museum of Modern Art, New York.)

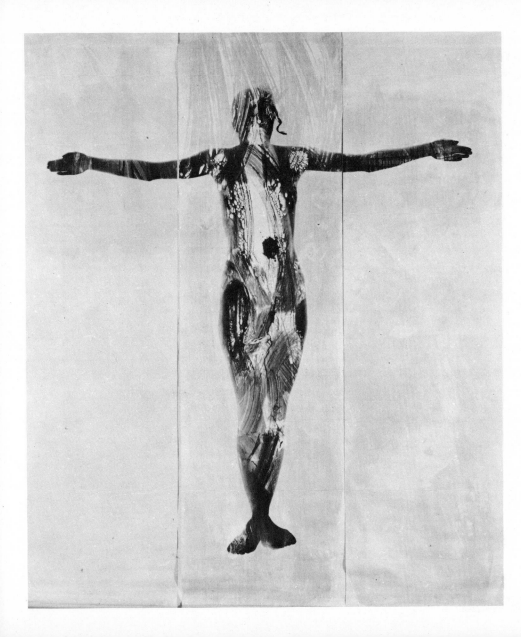

This page: Floris Michael Neusüss: "Photopeinture," 1965. (Permission of the artist.) A life-size figure was used to create photogram on a triple screen.

Opposite page, left: Floris Michael Neusüss: "Tellerbild," 1965. (Permission of the artist). Solarized photogram.

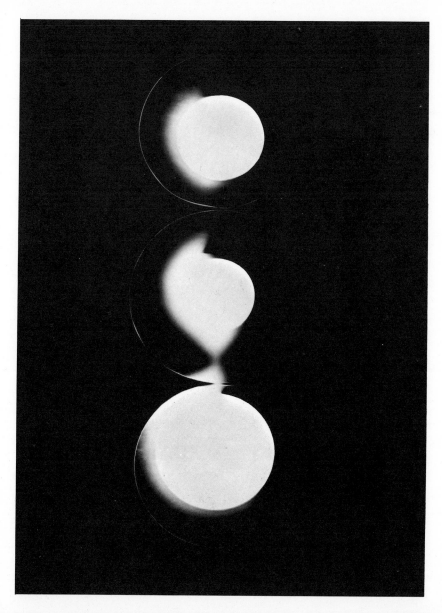

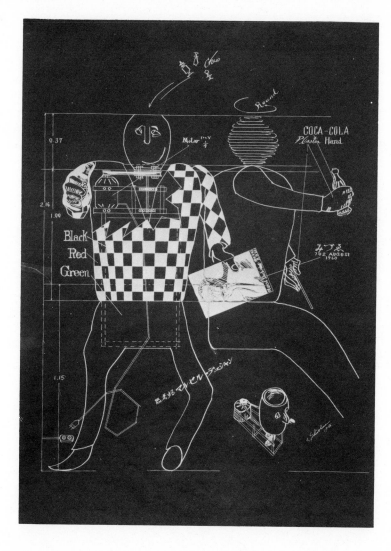

Above: Ushio Shinohara: "Marcel Duchamp," May 19, 1965. Blueprint, 24⅝" x 20¾". (Collection, The Museum of Modern Art, New York. Gift of the artist.)

11 Mounting Prints and Murals

Mounting a print on a stiff backing is a good way to prepare it for display. The easiest method is to place a sheet of dry mounting tissue between the print and the backing and to apply heat so the papers will adhere. In place of a commercial dry mounting press, you can use a regular household iron with the temperature control set between wool and silk.

Take a sheet of dry mounting tissue larger than the size of the print to be mounted. Place it on the back of the print, which should be laid face down on a table covered with newsprint or some other protection. With the flat tip of the iron, tack the tissue to the back of the print, by tapping the iron lightly against each corner or by drawing an "X" in the center and extending it to each corner. The tissue will adhere to the print well enough so that you can trim the excess margins off with a sharp scissors.

When the tissue has been trimmed to the same size as the print, position the print, face up, on mounting board (stiff, white paper). Then lay several sheets of medium-weight white paper, or a piece of lightweight cardboard over the print, and move the iron over the surface. Don't hesitate too long in one place, because too much heat can blister the photographic paper. Lift the covering to check the print as you press it, to see that it is adhering to the mount and that all the edges are down tight.

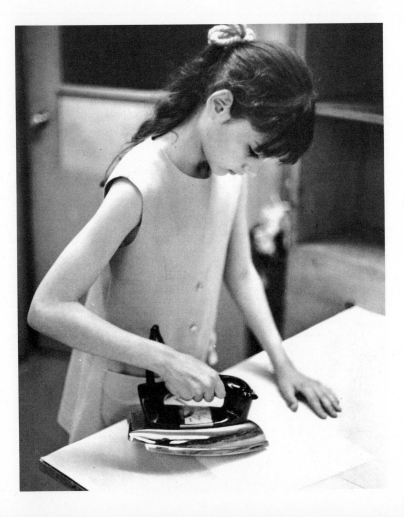

Dry mounting tissue is tacked to the back of a print with an iron. (Jane Black, fifth grade.)

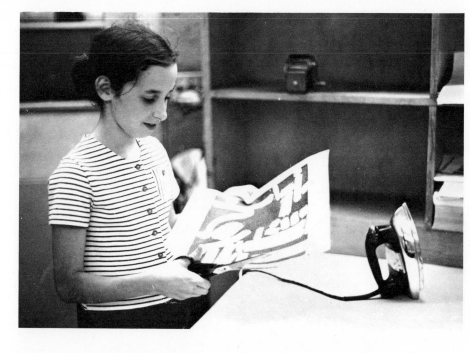

Excess tissue is trimmed off flush with edges of the print. (Lori Salzman, fifth grade.) The tissue-backed print is then placed face up on a mounting board.

Before you mount the print, you may decide that it would look better if it were cropped to show only a portion of it. Decide on the section you want to keep and trim away the excess parts neatly with a pair of scissors or a paper cutter. You can crop anywhere from one to four sides of the print to get the desired section.

If any prints have curled, you can straighten them out for mounting by sliding each one gently over the edge of a desk or a table. Be sure to hold the print at two diagonal corners while sliding it or the emulsion may crack.

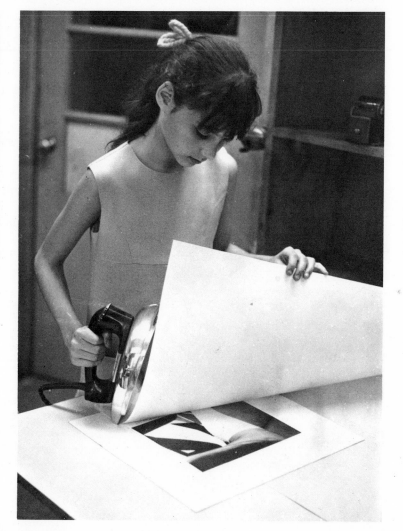

Print is covered while heat is applied with an iron, and cover is removed periodically so adhesion can be checked. (Jane Black.)

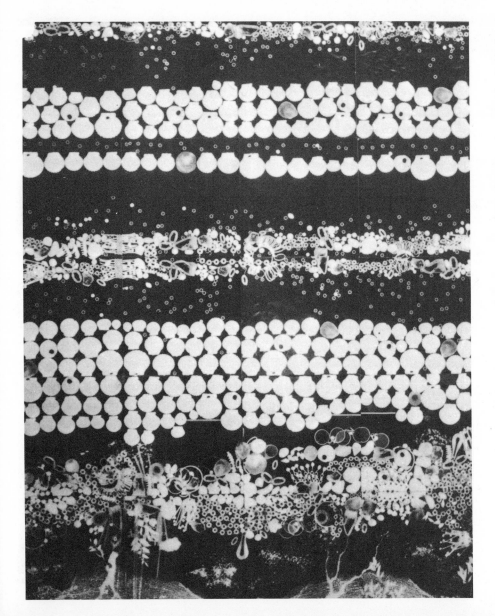

After prints have been mounted they can be displayed individually or they can be placed side by side to form an effective mural. However, murals can be even more visually exciting when the prints are specifically created so that they can be joined together for viewing.

This idea can be used with photographic compositions of any type and making the prints for the mural can become a game for a group of children. For instance, when making sun prints, one child would select a number of objects for his composition and would make a print. The next child to make a print would then select new objects, but would be required to use several of the first student's printing items. This would be continued with all the children in the group.

The prints can be numbered on the back with pencil, before processing, so there won't be any difficulty in establishing the order of the prints. (The graphite is not affected by the chemicals.) When the completed pictures are mounted next to each other, because of the continuity of the items, the images in the mural will appear to be related.

Another plan of continuous printing for a mural is to have the students arrange their designs on papers placed directly next to each other. Items placed on one paper could overlap onto the adjoining paper so that, when the prints are displayed, they will appear to be connected as one large print.

A single artist working on photograms can also create murals this way. He would just have to plan exactly what item would go partly off the edge of the paper and then place that item at the precise point in the next print.

Instead of being mounted individually, mural pictures can be dry mounted or rubber cemented to one large, sturdy board. They can also be pinned up side by side on a bulletin board to give the illusion of a mural.

Photogram murals achieve continuity in their separate elements by repetition of shapes. Mural on opposite page is in hinged frame.

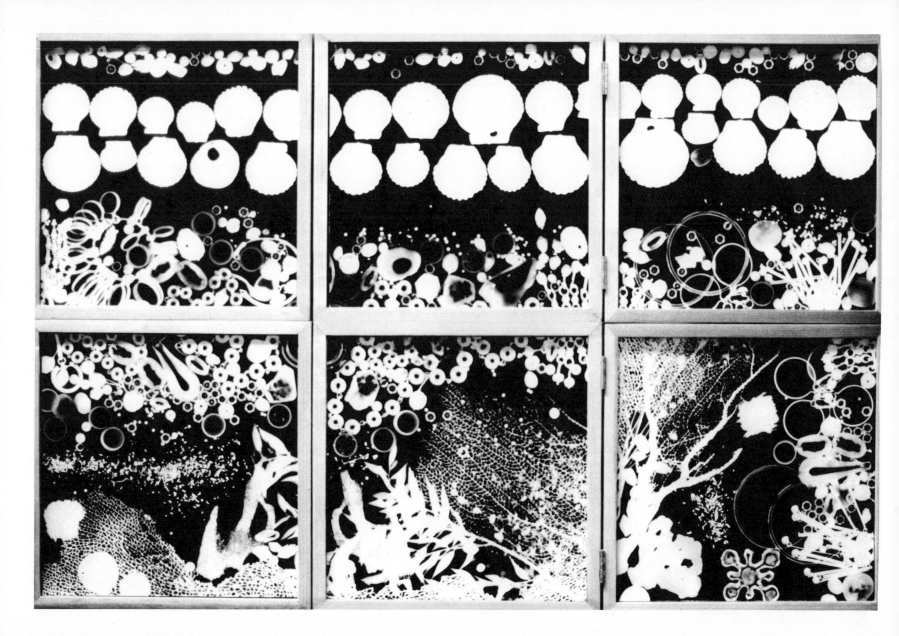

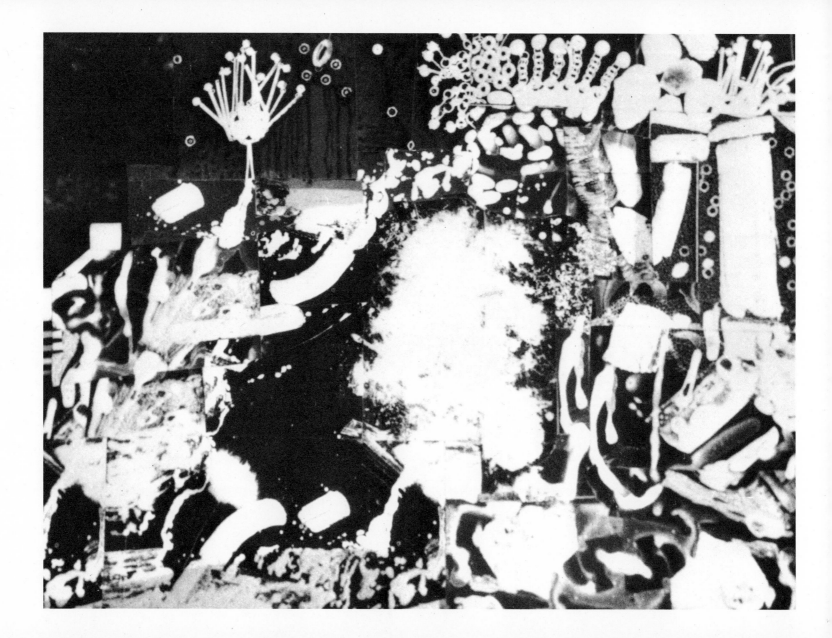

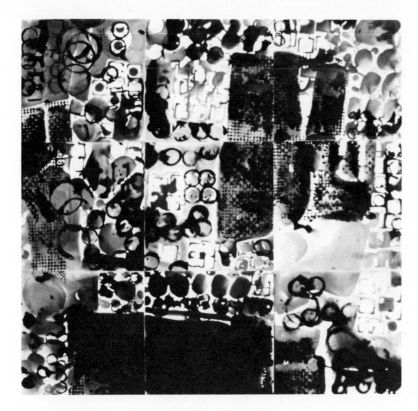

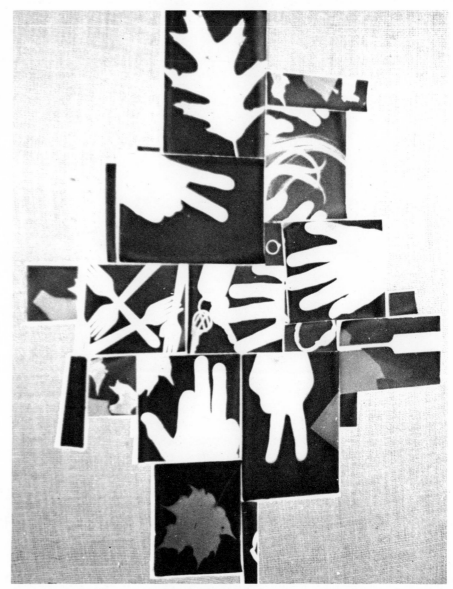

Above: Mural was formed from nine panels painted with color toners.

Right: Ten-year-old students at Burr Elementary School in Newton, Massachusetts, made separate photograms and assembled them into this mural, which was dry mounted on mat board. Project was directed by Mr. Ken Roberts.

Opposite page:
Montage was formed by combining parts of individual photograms.

Glossary

Acetic acid: A 28% solution of acetic acid (one of the earliest known acids) is diluted for use in photography as an acid stop bath.

Aperture: The opening in a lens which permits light to pass through. The size of the aperture can be varied by regulating the lens' diaphragm to control the amount of light transmitted.

Bleach: A chemical that solubilizes metallic silver. This removes the black content (metallic silver) of the photographic images, leaving only pure color.

Composition: The arrangement of a subject or subjects.

Condenser: Special lens of the enlarger used to focus the light onto the negative.

Contact paper: A relatively slow-speed photographic paper coated with a silver chloride emulsion.

Contact print: A print made by placing the negative in contact with light-sensitive paper. When making photograms, the original print is used as the negative.

Contact printer: A photographic device with a built-in light source used for exposing prints.

Continuous tone: A broad range of halftones between black and white.

Contrast: The ratio of light to dark (highlights to shadows) in a negative or a print.

Darkroom: A room in which all light has been excluded so that light-sensitive materials can be handled safely.

Deflected light: Light that has been turned aside or bent.

Density: Describes the opacity of a material.

Developer: A combination of chemical ingredients designed to change the silver halide that has been exposed to light (forming a latent image) to metallic silver, forming a visible image.

Diffused light: Scattered light that spreads out in all directions.

Direct coupling toner: A color toner that develops as well as colors the image by producing a silver image along with a dye image.

Dodger: The tool used for blocking light from areas of the print during exposure. Usually it is a thin wire with a piece of opaque paper or cardboard taped to the end of it.

Dodging: A method of limiting the amount of exposure given to localized areas of a print. During printing, a dodger is held between the light source and the paper and moved so that it casts a blurred shadow on the area of the print you do not want exposed.

Dry mounting: A method of mounting prints onto a mat board by the application of heat.

Dry mounting tissue: A thin waxy sheet of paper that will adhere to a surface when heat is applied.

Emulsion: Light-sensitive coating on the surface of paper or film. It consists of silver halide crystals supported in gelatin.

Enlarger: An instrument used in the darkroom for printing by the projection of light.

Enlarging paper (Projection paper): A high-speed paper coated with an emulsion consisting mainly of silver bromide.

Exposure: The transmission of light to a light-sensitive material to produce a picture. The duration of the exposure will depend on the intensity of the light.

Fix: To make an emulsion insensitive to light by removing the unused silver halides. The image on the emulsion thus becomes permanent.

Fixer: A solution of sodium thiosulfate which converts the un-exposed silver salts in the print to a soluble form so they can be washed out of the print. Some fixers have acid and hardeners added to neutralize the developer and to harden the gelatin emulsion.

Fog: Density due to unintentional exposure of film or paper.

F-stop: The size of the aperture as designated by an f-number. The smaller the number, the larger the opening.

Graduated measuring vat: A calibrated measuring container for liquids.

Halftone: Any tone that is not totally black or totally white.

Hot spot: A concentration of light that appears on a photogram because of uneven illumination. This can occur when the light source is too close to the paper or otherwise improperly positioned during exposure.

Hypo: Hypo is another name for fixer. It is an abbreviation for "hyposulfite of soda," which is a thiosulfate, a common fixing salt used in photography.

Latent image: An invisible picture formed on light-sensitive material by transmitted light. The structure of the exposed silver halide is changed by light so that the material can easily be reduced to silver by a developer, which makes the image visible.

Masking: Term used to indicate the blocking out of part of a photographic image.

Montage: A composition made up of pictures, or parts of pictures, to convey an overall impression.

Negative: 1. An image on film or glass (or other semi-transparent material) which can be used to make an unlimited number of prints. The tones in the negative are the reverse of those in the original subject. 2. Volume of empty space in which the solid or positive volumes of a picture are organized.

Negative carrier: A frame (either glass or metal) which holds a negative in place between the light source and the lens of an enlarger.

Opaque: Something through which light cannot pass.

Outdated paper: Photography paper that has passed its expiration date. The paper can no longer be guaranteed for good quality after this date.

Overexposure: An excessive amount of light reaching the paper or film during exposure causes the images to appear darker than they should upon development. The intensity of the light or the exposure time should be diminished.

Photoflood lamp: A high-voltage lamp used to give intense illumination.

Positive: 1. A print or transparency in which the tones of the image correspond to those of the original subject. A photogram usually produces a negative image. 2. The solid volumes of a picture.

Printing frame: A rectangular frame which supports a piece of glass. Paper and film are placed underneath the glass to keep them flat during exposure

Projection paper: Another name for enlarging paper.

Reflected light: Light that is cast back from a secondary surface.

Safelight: A light (yellow, brown, red, green, or orange) that can be used in the darkroom with papers and films.

Solarization: The reversal of an image by extreme overexposure. The Sabattier effect is also commonly called solarization. To produce the Sabattier effect, a developed image is exposed briefly to strong light without fixing, then returned to the developer. Lines will appear which separate a completely developed area from one that is just developing. (If the image is white, the lines will be dark, and vice versa.) The print is then fixed normally.

Standard toner: A color toner that converts the existing silver image into a dye image. Standard toner will also create a dye image from the silver salt in the emulsion.

Stop bath: An acetic acid bath used for neutralizing the alkali content of developer and therefore stop its chemical actions.

Timer: A clock or timing device enabling the photographer to keep track of correct processing and exposure times in minutes and seconds.

Tone: The different degrees of light and shade in a photograph. Synonym for value.

Tongs: Bamboo, plastic or stainless steel instruments used to transfer prints from one tray to another.

Toning: Coloring prints either through the application of dyes by hand or by placing the print directly in a toning solution.

Translucent: Partly transparent, enabling light to pass through but in a diffused form.

Transparent: Clear.

Tray siphon: A hose attachment, connected to the faucet, which siphons off the contaminated water in the tray and circulates clear water in the rinse bath for prints.

Value: The light and dark qualities of a photograph.

Visible image: Image developed either by the direct action of light on photosensitive material or by the action of chemicals on a latent image.

Supply Charts for Photographic Materials and Equipment

The following charts represent just some of the papers, films, and chemicals available on the market. These particular products are listed only because they relate to the contents of this book. Other photographic materials and equipment could apply as well.

Papers and films are listed primarily in sizes of 5 x 7 and 8 x 10 inches (8½ x 11 inches in some cases), and these are most commonly packaged in sheets of 25, 50, or 100. Papers and film are available in both rolls and sheets. Sheets of photographic paper can be purchased in sizes ranging up to 24 x 36 inches and in packages of up to 500 sheets per box. Film sheets can be obtained in sizes up to approximately 36 x 48 inches depending on the base of the film. Chemicals are also available in larger and smaller amounts than the ones listed but, again, the most common usable amount for the average photographer is the one specified on each chart.

Prices are subject to change by the manufacturers and approximate, current list prices are stated on the charts. Re-member, these items can sometimes be bought at a discount. Darkroom equipment can be purchased secondhand and make-shift items can sometimes be substituted. For example, enameled baking trays, or even shallow boxes lined with Saran Wrap or similar plastic, can be used instead of expensive photographic trays. An inexpensive kitchen timer and a wall clock can be utilized instead of an interval timer.

A local photography shop will usually carry a few types of Kodak enlarging paper or contact paper as well as the necessary chemicals. Roomlight handling papers and films, however, can be obtained only from graphic arts supply houses. A little research may be necessary in order to get roomlight materials and the more unusual photographic papers and supplies. Write to the manufacturer of a particular product for the location of the dealer nearest you. Also, check the back pages of current photography magazines for mail order houses that will forward reasonably priced equipment and supplies in the United States and Canada.

Papers

When selecting a type of paper to use for a photographic composition, you should consider the specific conditions required by the particular technique. A slow speed contact paper, for example, requires a relatively close light source and a longer exposure than the more sensitive enlarging paper. You would not normally select contact paper if you intended to project your design onto the paper with an enlarger. Conversely, you would not use enlarging paper, which should have a distant light source, to make a print with a contact printer.

Both types of paper come in different contrast grades from 0 (very low contrast) to 6 (very high contrast). This allows the photographer to obtain a specific, overall tonal effect in a print from a very muted one to one that shows a sharp contrast between white and black areas. Generally, a normal contrast paper (#2) is good for making photograms, but this depends on the objects used in the design. If fine plastics or translucent objects that don't transmit light well have been used, a #5 or #6 paper might be best. For solarization of prints, a high contrast paper (Agfa-Gevaert #6 or GAF #4 paper) is best. Variable contrast papers are also available. One sheet will produce any grade from 1 to 4, but these papers must be used with an enlarger and appropriate filters.

The weight of the paper will also be of concern in some cases. Most papers can be purchased in either of two weights: single (thin) or double (thick). Single-weight paper is less expensive. Light penetrates this paper easily so it is a good paper to use for an original photogram if the artist wishes to contact print it later. Double-weight paper is more substantial and it is easier than single-weight paper to keep flat after drying.

The surface quality of the paper — matte, lustre, or glossy — can be chosen according to the individual's own feeling about the presentation of his picture. Papers with a special surface — such as colored, fluorescent, silver, gold, or linen — can change the character of the final prints considerably.

A word should be said about the possibility of purchasing outdated photography paper. This practice is often dismissed by photographers, and sometimes rightly so, because of the fogging that could occur. However, the cost is very low and the paper will usually be in good condition if it has been stored properly. Government surplus stations are a good source for outdated paper and sometimes Air Force map, water-resistant, quick-drying paper can be had from them. This paper is excellent for making photograms in the classroom and, if purchased fresh, it would be considerably more expensive. Photography stores sometimes will also sell outdated paper at a low cost but remember there is some risk involved.

Films

Films used in making photograms are photosensitized sheet films that can be used in the darkroom with a safelight or handled in roomlight. They are normally used in graphic arts, drawing and reproduction, and advertising. These films, like the roomlight papers, must be purchased at graphic art supply houses rather than in standard photography stores.

Process films (graphic films) come in gradations from high contrast to continuous tone. Lith films (line films) are high contrast films. If they are used with a paper developer, a more continuous tone can be obtained with all of them. The listed films were selected for variety. They are clear, translucent, or semi-opaque and some accept the addition of color. Most can be purchased in thin or fairly thick weights.

Basic Photography Equipment

ITEM	DESCRIPTION
Trays	Plastic 8x10
	10x12
	11x14
	14x17
	16x24
Print tongs	Plastic, bamboo, stainless steel
Stirring paddle	Plastic
Storage bottles	Opaque, plastic; gallon-size
Tray siphon	Plastic
Funnel	Plastic
Timer	
Measuring vat	1 quart, plastic; graduated
Thermometer	
Contact Printing Frame	8x10 inches
Contact Printer	5x7 inches
Enlarger	
Photoflood lamp	375 watts (G.E. or Sylvania)
Ruby bulb	25 watts (G.E.)
Light stand	telescope mount
Reflector shade	metal, 12-inch diameter
Spring clamp and socket	

Enlarging (Projection) Papers

MFGR.; BRAND	SURFACE	WEIGHT	CONTRAST	SIZE	SHEETS PER PKG.
Cold Tone					
Agfa-Gevaert; Brovira	Glossy or Lustre	S or D	1—6	5x7 8x10	25 25
Du Pont; Velour Black	Glossy, Lustre, or Semi-matte	S or D	1—4	5x7 8x10	100 25
GAF; Jet	Glossy	S	1—4	5x7 8x10	100 25
Kodak; Kodabromide	Glossy or Lustre	S or D	1—5	5x7 8x10	25 25
Warm Tone					
GAF; Air Map Special	Semi-gloss	S	2—4	8x10	25 100
GAF; Cykora	Glossy or Lustre	S or D	1—4	5x7 8x10	100 25
Kodak; Medalist	Glossy or Lustre	S or D	1—4	5x7 8x10	25 25
Supreme; Supre-Brome	Glossy	S	Continuous tone	5x7 8x10	100 100

Contact Papers

MFGR.; BRAND	SURFACE	WEIGHT	CONTRAST	SIZE	SHEETS PER PKG.
Agfa-Gevaert; Contactone	Glossy	S D	1—2	4x6 8x10	500 250 (D.W.)
GAF; Cyko, Type 1100	Glossy	S	1—4	5x7 8x10	100 100
Kodak; Azo	Glossy or Lustre	S or D	1—5	5x7 8x10	25 25
Kodak; Velox	Glossy	S	1—4	5x7 8x10	25 25
Luminos; Contact Paper	Glossy	S	0—3	8x10	500

Special Surface Enlarging Papers

MFGR.; BRAND	SURFACE	COLOR	WEIGHT	SIZE	SHEETS PER PKG.
Luminos; Pastel	Matte	Blue, green red, yellow	S	8x10	100 25 of each color
Spiratone; Gold-Brome, Silver-Brome		Gold, silver	D	8x10	25 (D.W.) 100 (ass.) (D.W.)
Spiratone; Psycho-Brome	Semi-matte	Fluorescent red, yellow, green	S	8x10	25
Supreme PM; Psychedelic Color	Semi-matte	Gold, silver	S	8x10	100

Roomlight Handling Papers

MFGR.; BRAND	SURFACE	WEIGHT	SIZE	SHEETS PER PKG.
Agfa-Gevaert; Rapido Print TC4	Matte	Light	8x10	100
Agfa-Gevaert; FC1 Grades 2, 3, 4	Glossy	S	5x7 8x10	100 100
Kodak; Kodagraph Auto-positive A1		Ultra thin	11x14 24″x100′	100 (one roll)
Kodak; Kodagraph Auto-positive AQ1		Ultra thin	12x18 24″x100′	50 (one roll)
Kodak; Kodagraph Repro-Negative R1		Ultra thin	8½x11	100
Supre-Print; Type DS, extra hard	Matte, high contrast	Document	8x10	100
Supre-Print; Type G, extra hard	Translucent, high contrast vellum	Light	8x10	100
Supre-Print; Type A, extra hard	Glossy, continuous tone	S	8x10	100

Printing Out Papers (can also be handled in roomlight)

MFGR.; BRAND	SURFACE	WEIGHT	SIZE	SHEETS PER PKG.
Agfa-Gevaert; P.O.P.	Glossy	S	5x7 8x10	100 100
GAF; Proof Glossy	Glossy	S	5x7 8x10	500 100
Kodak; Studio Proof	Glossy	S	5x7 8x10	25 25
Blueprint Paper	Blue	S		
Diazo Paper	*Blue on white *Black on white *Black on pink Black on yellow Blue on yellow Blue on pink Red on white	20-lb. stock	8½x11	100

*Most commonly available

Films: Roomlight Handling

MFGR., BRAND	DESCRIPTION	THICKNESS	SIZE	SHEETS PER PKG.
Kodak; Kodagraph Auto-positive 2576	Matte	.004	8½x11	50
Kodak; Kodagraph Auto-positive 2920	Clear, high contrast	.004	8½x11	50
Diazo Chrome	Acetate-clear; brown, yellow, red, blue, black, green, orange, violet		8½x11	25

Films: Darkroom Handling

MFGR.; BRAND	DESCRIPTION	THICKNESS	SIZE	SHEETS PER PKG.
Agfa-Gevaert; TP7P Projection Speed Film	Clear, high contrast	.004	5x7 8x10	50 50
Du Pont; Adlux	Translucent	.004	5x7 8x10	25 25
Du Pont; Cronapaque	White, semi-opaque	.007	8x10	25
Du Pont; Cronar Ortho S, Litho	Clear, high contrast	.004	5x7 8x10	50 50
GAF; Graphic P-407 Litho Film	Clear	.004	5x7 8x10	100 100
GAF; Litho Film A-557		.0055	5x7 8x10	100 100
Kodak; Kodagraph Contact Film 2580	Matte, high contrast	.004	8½x11	50
Kodak; Kodalith Auto Screen Ortho Film 2563	Clear; 133 lines per inch	.004	4x5 8x10	25 25
Kodak; Kodalith Ortho Type 3	Clear, high contrast	.0053	5x7 8x10	50 50
Kodak; Kodalith Translucent Material	Between a paper and film		8½x11	100
Supre-Lith; Ortho Film 303	Clear, acetate	.005	8x10	50

Chemicals

MFGR.; BRAND	DESCRIPTION AND AMOUNT
Paper Developers	
FR Paper Developer	Liquid concentrate to make 1 gal.
GAF; Ardol	Powder to make 1 gal.
Kodak; Dektol	Powder to make 1 gal.
Kodak; Selectol	Powder to make 1 gal.
Kodak; Versatol	Liquid concentrate to make 1 gal.
Universal Developers (for Paper or Film)	
Du Pont; 53-D	Powder to make 1 gal.
GAF; Vividol	Powder to make 1 gal.
Kodak; Dektol Tri-Chem Pack	Powder to make 8 oz. each of developer, stop bath, fixer
Stop Bath (Acetic Acid 28%)	
FR; Short Stop with Color Indicator	Liquid concentrate; 8 oz.
Kodak; Indicator Stop Bath	Liquid concentrate; 16 oz.

MFGR.; BRAND	DESCRIPTION AND AMOUNT
Fixer	
Du Pont; 18-F	Powder to make 1 gal.
FR; Fixol	Liquid concentrate to make 1 gal.
GAF; Acid Fixer with Hardener	Powder to make 1 gal.
Kodak; Fixer	Powder to make 1 gal.
Kodak; Sodium Thiosulfate Crystals	1 lb. of crystals makes 1 gal.
Kodak; Rapid Fixer	Liquid concentrate to make 1 gal.
Processing Aids	
Edwal; Liquid Orthazite (anti-foggant)	Liquid concentrate; 4 oz. 1 qt.
Edwal; Hypo-Chek (checks fixer for exhaustion)	Liquid concentrate; $3/4$ oz. 4 oz.
Edwal; Single Solution Tray Cleaner	Liquid concentrate; 1 pt. bottle
FR; Print Flattener	Liquid concentrate; 8 oz. 26 oz.

Chemicals

MFGR.; BRAND	DESCRIPTION AND AMOUNT
Washing Aids	
FR; Hypo Neutralizer	Liquid concentrate; 8 oz. 26 oz.
GAF; Wash Saver	Powder to make 5 gal.
Kodak; Hypo Clearing Agent	Powder to make 5 gal.
Bleach	
Agfa-Gevaert; Bleach-Fix (PPa-III/KM)	Liquid concentrate to make 1 gal.
Kodak; Ektaprint C Bleach	Powder to make 1 gal.

Colorants

MFGR.; BRAND	DESCRIPTION AND AMOUNT
Edwal; Color Toners (red, green, yellow, brown)	Liquid concentrate; 4 oz.
FR; Develochrome, direct toning developer (red, green, blue, yellow, sepia)	Powder to make 12 oz. of toner and 12 oz. of fixer Powder to make 1 gal.
Kodak; Sepia Toner	Powder to make 1 qt. toner
Kodak; Retouch Colors (magenta, yellow, red, orange, brown, neutral, green, cyan, blue)	Pressed form; 1 jar
Vegetable Coloring (all colors)	Liquid concentrate; 1 bottle

Miscellaneous Items of Interest

ITEM-MFGR.	DESCRIPTION	AMOUNT	APPROX. PRICE
Rockland; Photo-Aluminum	Photo-sensitive aluminum; polished or matte surface; 9x12 sheet	10 sheets per package	$30.00
Rockland; Print-E-Mulsion CB-101	Medium-fast speed sensitizer for surfaces (glass, metal, etc.)	1 pt.	$12.00
Rockland; FA-1 Fabric Sensitizer	(Makes fabric sensitive to light)	1 gal.	$22.00
Dry Mounting Tissue	Heat-sensitive adhesive paper; in size 5x7 in size 8x10 in size 11x14	25 sheets	$ 2.30 $ 4.95 $ 9.35
3 M Rainbow Color- Key Pack	Light-sensitive, transparent, colored film; negative acting; size 8x10	25 sheets in assorted colors	$20.75
3 M Color-Key Developer	Develops 3 M Rainbow film	1 qt.	$ 2.65
Colored Acetate	Transparent adhesive sheets		$.70

List of Manufacturers

Agfa-Gevaert, Incorporated
275 North Street
Teterboro, New Jersey 07608

Eastman Kodak Company
343 State Street
Rochester, New York 14650

Edwal Scientific Products
12120 South Peoria Street
Chicago, Illinois 60643

E. I. Du Pont de Nemours & Co.
Photo Products Department
Wilmington, Delaware 19898

The FR Corporation
951 Brook Avenue
Bronx, New York 10451

GAF Corporation
Industrial Photo Division
Customer Service
140 West 51st Street
New York, New York 10020

Luminos Photo Corporation
25 Wolffe Street
Yonkers, New York 10705

Rockland Colloid Corporation
599 River Road
Piermont, New York 10968

3 M Printing Products Division
3 M Center
St. Paul, Minnesota 55105

Spiratone Incorporated
135-06 Northern Boulevard
Flushing, New York 11354

Supreme Photo Products
543 West 43rd Street
New York, New York 10036

Supre-Print Stabilization Products
543 West 43rd Street
New York, New York 10036

Bibliography

Bayer, Herbert; Gropius, Ise; and Gropius, Walter, ed. *Bauhaus 1919-1928*. Boston: Charles T. Branford Co., 1959.

Cooke, Robert W. *Designing with Light on Paper and Film.* Worcester: Davis Publications, 1969.

Croy, Otto R. *Design by Photography*. London & New York: Focal Press, 1963.

Eder, Josef Maria. *History of Photography*. New York: Columbia University Press, 1945.

Focal Press. *Focal Encyclopedia of Photography*. New York: McGraw Hill, 1969.

Gernsheim, Helmut. *Creative Photography: Aesthetic Trends, 1839-1960.* London: Faber & Faber, 1962.

Gernsheim, Helmut and Alison. *The History of Photography from the Earliest Use of the Camera Obscura in the 11th Century up to 1914.* London: Oxford University Press, 1955.

Kepes, Gyorgy. *Language of Vision.* Chicago: Paul Theobald, 1944.

Life Library of Photography. *Color.* New York: Time Inc., 1970.

Life Library of Photography. *The Print.* New York: Time Inc., 1970.

Life Library of Photography. *Light and Film.* New York: Time Inc., 1970.

Moholy-Nagy, László. *Vision in Motion.* Chicago: Paul Theobald, 1947.

Newhall, Beaumont. *The History of Photography.* New York: Museum of Modern Art, Doubleday, 1964.

Sloane, O'Coner T., ed. (Orig. ed. Hiscox, Gardner D.) *Henley's Twentieth Century Book of Formulas, Processes, and Trade Secrets.* Rev. ed. New York: Books Inc., 1957, 1970.

Towler, J., M.D. *The Silver Sunbeam.* Facsimile ed. Hastings-on-Hudson: Morgan & Morgan, 1969.

Index